T0079728

BOSNIAN
BETWEEN TWO WORLDS
BY PATRICK McCARTHY & AKIF COGO
ST.LOUIS

MISSOURI HISTORICAL SOCIETY PRESS
ST. LOUIS, MISSOURI
DISTRIBUTED BY UNIVERSITY OF CHICAGO PRESS

© 2022 by Missouri Historical Society Press
ISBN 979-8-9855716-1-5
All rights reserved 26 25 24 23 22 · 1 2 3 4 5

Library of Congress Cataloging-in-Publication Data
Names: McCarthy, Patrick, 1961- author. | Cogo, Akif, 1983- author.
Title: Bosnian St. Louis : between two worlds / Patrick McCarthy, and Akif Cogo.
Description: St. Louis, Missouri : Missouri Historical Society Press, [2022] | Includes index. |
 Summary: "The Bosnian community in St. Louis is the largest concentration of
 Bosnians outside of Bosnia and Herzegovina. Many Bosnians came to St. Louis
 beginning in the mid-1990s to escape a systematic campaign of genocidal attacks
 and quickly established themselves as a positive presence in the city, bringing with
 them tight-knit families, a strong work ethic, and practical occupational skills. This
 book looks deeply into the complex question of memory as it shapes the lives of those
 impacted by the Bosnian genocide"—Provided by publisher.
Identifiers: LCCN 2022021504 | ISBN 9798985571615 (paperback)
Subjects: LCSH: Bosnian Americans—Missouri—Saint Louis—History. | Bosnians—
 Illinois—Missouri—Saint Louis—History. | Refugees—Missouri—Saint Louis—Social
 conditions. | Yugoslav War, 1991-1995—Refugees. | Saint Louis (Mo.)—Ethnic relations. |
 Saint Louis (Mo.)—History. | BISAC: HISTORY / United States / State & Local / Midwest
 (IA, IL, IN, KS, MI, MN, MO, ND, NE, OH, SD, WI) | HISTORY /General
Classification: LCC F474.S29 B675 2022 | DDC 304.809778/66—dc23
LC record available at https://lccn.loc.gov/2022021504

Unless otherwise noted, all photos by Patrick McCarthy.
Cover photos: Stari Most Bridge in Mostar, Herzegovina, courtesy of Domingo Leiva;
St. Louis skyline, photo by f11photo, iStock, Getty Images Plus, via Getty Images.

Designed by Thomas White
Distributed by University of Chicago Press
Printed and bound in the United States by Modern Litho

TABLE OF CONTENTS

DEDICATED TO THE MEMORY OF

NIRVANA ZELJKOVIĆ
1983-1995

AND

SELMA DUČANOVIĆ
1987-1998

Nirvana Zeljković (1983-1995). Photo courtesy of the Zeljković family.

Selma Dučanović (1987-1998). Photo courtesy of the Dučanović family.

SVAKA TUĐA ZEMLJA TUGA JE GOLEMA...
EVERY FOREIGN LAND IS A HUGE SORROW...
(TRADITIONAL BOSNIAN FOLK SONG)

No one knows what it means to be born
and to live on the brink, between two
worlds … to hesitate and waver all one's
life. To have two homelands and yet have
none. To be everywhere at home and
to remain forever a stranger.

—IVO ANDRIĆ, BOSNIAN NOBEL PRIZE LAUREATE,
FROM *BOSNIAN CHRONICLE*

If home is a wound that splits open the
world, the wound neither stays open
nor heals over. The world rearranges
itself. It doubles up on itself. It makes
space for the unthinkable and the impure.
We live under two moons. Survival
dictates to casually deny this, but there
are people everywhere who know
the truth. I recognize fellow aliens and
we nod to each other.

—SAIDA HODŽIĆ,
FROM *THE DISORDER OF THINGS*

As a diasporic person, you learn that it's in fact really easy to leave your country. What is difficult is leaving its history, as it follows (or leads) you like a shadow. The history of Bosnia has always confounded me. I sometimes feel that I seek an impossible connection, because I've been displaced since a young age. Its progress and drastic change since the war have eluded me. But over the years, the further Bosnia distanced itself from me, the greater my curiosity grew. And now despite its various political and ethnic complications, Bosnia won't let go of me.

—ENNIS CEHIĆ,
FROM *NEW METONYMS: BOSNIA & HERZEGOVINA*

Mina Jašarević from Srebrenica in her home in St. Louis, 1998. Photo by Tom Maday.

INTRODUCTION

BY ALEKSANDAR HEMON

The world is full of people who will die in a place where they never expected to live. The world is sown with human beings who did not make it *here*, where we are, wherever that may be. Among those people are many Bosnians, for whom the *displace* is St. Louis, *here* in the US, where many ended up in the 1990s because of the war that made Bosnia known for all the wrong reasons.

Bosnians are one of the many refugee nations: Roughly one-quarter of the country's pre-war population is now displaced, strewn all over the globe. There is no Bosnian without a family member living elsewhere. Entire Bosnian towns and villages were displaced in the war, neighborhoods undone with all of the life they housed, their population scattered, going wherever they could, if they could. Each time I meet a Bosnian, I ask: *So, how did you get here?* The stories are often long, fraught with elisions, edited by the presence of the many new-life-in-the-new-land modalities. People get overwhelmed while telling them, remembering things they didn't know they could—or would want to—remember, insisting on details that are both extremely telling and irrelevant, yet soaked with meanings that are not always immediately apparent. In each of those of departure and arrival stories an entire history is inscribed, whole networks of human lives and destinies outlined. And each individual story is a story of a community—no one lives alone in the world, certainly not Bosnians.

The recent global and systemic upsurge in xenophobia and bigotry directed at migrants and refugees is predictably contingent upon their dehumanization— the powers that be, or want to be, present them and think of them as a mass

of nothings and nobodies, driven, much like zombies, by an incomprehensible, endless hunger for what "we" possess, for the amenities of "our" good life. But each person, each family, each town, each community, have their own history, their own set of stories that define them and locate them in the world, their own networks of love and friendship, their own human actuality and potential. To reduce them to a shapeless mass, to deprive people with names, homes, and families of their stories, is the beginning of a crime against humanity and history.

Migration generates narratives. Each displacement is a tale; each tale is unlike any other. The journeys are long and eventful, experiences are accumulated, lives reevaluated and reconfigured, worlds torn down and re-created. Each story of making it here is a narrative entanglement of memory and history and emotions and pain and joy and guilt and ideas undone and reborn. Each story complements all the other ones—the world of refugees is a vast narrative landscape.

What *Bosnian St. Louis: Between Two Worlds* has done is aggregate the stories of Bosnians in St. Louis—more than 60,000 today—into a complex and triumphant narrative of rebuilding lives, individual and communal, in a new place and a new land. The value of such a project is enormous because the fear of every refugee is that they and their lives will be forgotten, that they will be disregarded by future histories just as they were violated by the present one. Their previous life, rooted in a place to which they no longer have access, will at best become a story and/or a memory. Their present life, in a host land, might feel unreal, at least at first, if there are no stories and memories of being here. Their life here might also be dismissed or discarded, because what disqualifies it in the eyes of xenophobes and bigots is not only the presumably essential foreignness of refugees but also their indelible connection to the place of origin to which they never said a proper goodbye.

Bosnian St. Louis: Between Two Worlds provides an opportunity for a shared, communal memory of arriving to a new home while remembering and cherishing the old one. It contains a story of the life of a community that will not and cannot be discarded. The lives of Bosnians in St. Louis will now never be forgotten, their presence undeniable in perpetuity, and the connections between here and there—the fraught continuity between the previous and the new life—laid out for all to see in living memory.

Aleksandar Hemon is a professor of creative writing at Princeton University. He is the author of *The Lazarus Project*, a finalist for the 2008 National Book Award and National Book Critics Circle Award, and three collections of short stories: *The Question of Bruno*, *Nowhere Man*, and *Love and Obstacles*. His other books include works of nonfiction, *My Parents: An Introduction/This Does Not Belong to You* and *The Book of My Lives*. He is a co-writer of the film *The Matrix Resurrections*. Originally from Sarajevo, Hemon is a past recipient of a Guggenheim Fellowship and a genius grant from the MacArthur Foundation.

PREFACE:
WHY THIS BOOK?

The war and genocide in Bosnia and Herzegovina from 1992 to 1995 created 2 million refugees. It resulted in Europe's largest refugee crisis since the end of the Second World War.

If you were to stick pins in a wall map of all the places throughout the world where Bosnians have been scattered by the war and genocide of the 1990s, it would form a global empire of displacement, sorrow, and memory. The unlikely capital of that empire would be St. Louis, which is now home to more displaced Bosnians than any other city in the world. In 2022 the size of St. Louis's Bosnian community was an estimated 60,000 people.

An exact figure is difficult to determine because the total number includes successive waves of war refugees who began arriving in the early 1990s. First came a small number of political and economic immigrants before the war, then starting in 1993 Bosnian refugees who directly resettled in St. Louis. Next were those who came by way of Germany at the end of the 1990s, when the German government controversially ended its temporary protection for refugees from Bosnia and Herzegovina. After the war Germany began repatriating Bosnians to their hometowns, places that were still occupied by the very aggressors who had driven them out in the first place. Instead, thousands of refugees chose to come to St. Louis to join family and friends who were already living here.

St. Louis's Bosnian community is also composed of thousands of secondary migrants who made their way here from other American cities where they had

first been placed. They were drawn to St. Louis by the low cost of housing, the availability of jobs, and the appeal of a re-created Bosnian community in exile.

The Bosnians brought with them powerful connections to a shared culture and painful memories of war. The large and important Bosnian diaspora community in St. Louis continues to grow as the next generation of Bosnian Americans—the children of refugees—have children of their own.

Memories of home continue to shape the experiences and outlooks of Bosnians in St. Louis. One woman in St. Louis still carries the key to her house in Bosnia. Another man describes his feelings toward Bosnia as a divorce he did not want from a woman he still loves. Memories like these tell us something essential about the human experience after war and displacement.

Before the war Bosnia and Herzegovina was a multiethnic society of mutuality and inclusion. It was a small, beautiful country in the heart of Europe, made up of people from different backgrounds and faith traditions. The fabric of that society was torn apart by nationalist aggressors who took large swaths of Bosnia as their own. They committed genocide and other war crimes to get what they wanted, and in the process damaged and violated the idea of a shared life in Bosnia and Herzegovina.

The war and genocide in Bosnia and Herzegovina had worldwide significance. It helped define post–Cold War international relations and the priorities (and limitations) of US and European foreign policies. Most important, it revealed the world's failure to halt another genocide in Europe just 50 years after the Holocaust.

This book looks at the human costs and consequences of genocide. Where do the survivors go? What memories do they carry with them, and how do those memories shape their lives?

People don't often consider realities like these because we know that such events can happen anywhere. Even worse, we understand on some level that it is unlikely that any outside power would come to our aid if we ever faced such grave danger. The International Criminal Tribunal for the former Yugoslavia has largely concluded its work. But even today, those who carried out the genocide are denying that it ever occurred or are brazenly celebrating it with a growing chorus of support throughout the world.

This book honors the experiences of those who came to St. Louis after the war and genocide in Bosnia and Herzegovina, and it recognizes the courage, tenacity, and resourcefulness that refugees have shown in starting their lives over in a strange land. Everyone wants a sense of belonging. We carry experiences with us that shape and define who we are. The story of Bosnia's past—and the Bosnians who have made their home here—is inseparably tied to St. Louis. It is bound together with our present and future.

Beyond personal and collective tragedy, we all want a place to call home.

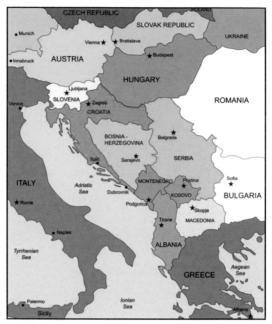

Map of Bosnia and Herzegovina in southeastern Europe. Map courtesy of flat-project.org.

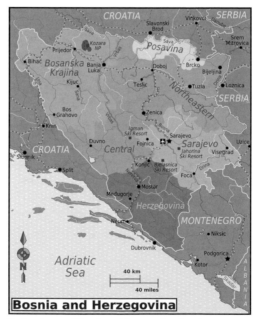

Regional map of Bosnia and Herzegovina. Bosnia primarily covers the country's northern region, and Herzegovina makes up its southern region. Map courtesy of Stefan Ertmann.

HISTORICAL
BACKGROUND

WHERE IS BOSNIA?

- Bosnia and Herzegovina is located in southeastern Europe, in the western part of the Balkans. The country is often informally referred to as simply "Bosnia."

- Sarajevo is its capital and largest city.

MANY MISCONCEPTIONS SURROUND BOSNIA AND HERZEGOVINA, ITS HISTORY, AND ITS PEOPLES.

- Its own country from the 12th century, Bosnia became a medieval kingdom in 1377. Bosnia's geographic boundaries have been set since then.

- Bosnia and its core lands have been together since the 13th and 14th centuries. It was first its own kingdom, then part of the Ottoman and Austro-Hungarian empires. Next it was part of different Yugoslavias: the Kingdom of Serbs, Croats, and Slovenes; the Kingdom of Yugoslavia; and the Socialist Federal Republic of Yugoslavia. It has been the independent country of Bosnia and Herzegovina since 1992.[1]

- Bosnia primarily covers the country's northern region, and Herzegovina makes up its southern region.

[1] Noel Malcolm, *Bosnia: A Short History* (New York: Macmillan, 1994).

WHO IS A BOSNIAN?

- A Bosnian is someone who lives in, or is from, Bosnia and Herzegovina. It is not a religious or ethnic label.

- Defined by geographic boundaries, Bosnians have been a distinct people since the 10th century.[2]

- Bosnia and Herzegovina is the only former Yugoslav republic that was established on the basis of geography and history rather than ethnicity.[3]

- Before the 1992–1995 war, Bosnia and Herzegovina had a population of 4.4 million. It was made up of three major ethnic groups: Muslim Bosniaks (44 percent); Orthodox Christian Serbs (31 percent); Roman Catholic Croats (17 percent); as well as Jews, Roma, Ukrainians, Albanians, Poles, Italians, and others.

- Bosniaks are descendants of local Slavs who adopted Islam after the Ottoman conquest of Bosnia in the 15th century.

- Bosniaks are neither ethnic Turks nor Serbs or Croats. Rather, they're their own national group with a distinct history and culture. Their roots trace in part to the Bosnian church, a medieval Christian church that was considered heretical by both the Eastern Orthodox and Catholic churches of the time.

- Likewise, Bosnian Catholic Croats and Bosnian Orthodox Serbs have their own unique histories and cultures.

- Bosnian and Herzegovinian society is a mosaic of different groups that have various identities and beliefs. Its shared culture is more than the sum of its parts—it's a diverse, enigmatic, and captivating combination of them.

[2] John Fine, "What Is a Bosnian?" *London Review of Books* 16, no. 7 (April 28, 1994).

[3] Lynn Maners, *The Bosnians: An Introduction to Their History and Culture* (Washington, DC: Center for Applied Linguistics, 1993).

- The 1992–1995 war and its outcome was an attempt to divide and subdivide Bosnians into ethnonationalist groupings contrary to their historical character and the ethos of Bosnia and Herzegovina. Because Bosniaks were the principal targets of the genocidal aggression during the war, they are the biggest group of Bosnians who came to St. Louis as refugees.

- The Bosnian community in St. Louis also includes smaller numbers of Catholic Croats, Orthodox Serbs, and Bosnian families of mixed heritage.

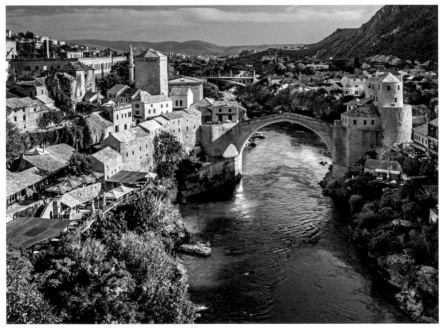

The Stari Most Bridge in Mostar, Herzegovina, was completed in 1566. Photo courtesy of Domingo Leiva.

A Bosnian Catholic in traditional dress. Photo courtesy of Zvonko Marić.

CHAPTER 1

EARLY ARRIVALS

St. Louis has always been an immigrant city. Founded in 1764 as a French fur-trading post, people from all over Europe flocked to the growing town. Located on the Mississippi River, it quickly became a center of commerce. By 1850 half of St. Louis's population was born abroad, mainly in Germany and Ireland. Fifty years later St. Louis had become the fourth largest city in America.[4]

When South Slavic immigrants came to St. Louis in the 1860s, they arrived on Mississippi River steamboats bound for St. Louis from New Orleans and established a community downtown near 2nd and Market streets. These Slavs were secondary migrants from the Lower Mississippi Delta, where they were known as "tacos": When asked how they were doing, their typical response was *tako, tako*—"so-so" in their native language. Most had come from the Dalmatian region of southern Croatia and were experienced seamen and stonemasons.[5]

Census and immigration records show that there were relatively large numbers of Croatians and Serbians living in St. Louis during the second half of the 19th century and the first half of the 20th century. The first known "Bosnian" to settle in St. Louis was Conrad Schmidt. He was of German heritage and had a nontraditional name for someone born in Bosnia.

[4] See Elizabeth Terry, et al., *Ethnic St. Louis* (St. Louis: Reedy Press, 2015).

[5] Peter Jenkins, *Along the Edge of America* (Boston: Houghton Mifflin, 1997), 232.

According to the 1860 Census, Schmidt was born in 1822 in Herzegovina—the southern part of Bosnia and Herzegovina, which was then part of the Austro–Hungarian Empire. He lived in a north-side neighborhood along the Mississippi River. Conrad and his wife, Cathar, had two children, Marie and John. Their St. Louis neighbors were also German speakers. Over the next century, his birthplace would become part of the first iteration of Yugoslavia: land of the South ("Yugo") Slavs ("Slavia") that was formed as "a Kingdom of Serbs, Croats, and Slovenes."

During World War II, Bosnia was an occupied region of the Nazi puppet state of Croatia. Then it was a centerpiece of Communist Yugoslavia, and later it became the independent country of Bosnia and Herzegovina. Modern Bosnia and Herzegovina is one of the six republics of the former Yugoslavia, born out of the violent dissolution of Yugoslavia created under Josip Broz ("Tito"). The country's origins lay in the medieval Kingdom of Bosnia, which was shaped over time by its location within the dynamic intersection of Roman, Persian, Byzantine, Ottoman, and Austro-Hungarian empires, and populated by adherents of Catholicism, Orthodox Christianity, Islam, and Judaism.

Conrad Schmidt might have come to St. Louis to escape persecution, to avoid military service in an imperial army, to seek religious freedom, or simply to embrace the opportunities of life in a new city. He scarcely could have imagined that St. Louis would one day be home to tens of thousands of people from the country of his birth, seeking refuge from genocidal violence that would consume and destroy his homeland.

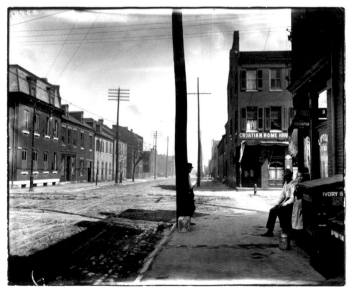

Croatian Home at 1825 2nd Street in St. Louis, around 1910. Missouri Historical Society Collections.

"In Bosnia pacts on friendship are made which even death cannot break."[6]

—*ST. LOUIS POST-DISPATCH*, SEPTEMBER 10, 1899

The Nucleus of the Bosnian Community in St. Louis Forms

In 1904 a group of Christian Orthodox Serbs from Herzegovina came to St. Louis, including Marko Bolanović, Nikola Guzina, Mitar Kopricica, and Blagoj Košutić.[7] There were a handful of other immigrants in St. Louis who had listed Bosnia as their birthplaces on the census. According to the 1920 Census, Othelia Suneritz, age 15, the daughter of Matthias (born in Hungary) and Marie (born in Austria), was born in Bosnia in 1905.

Elsewhere the census recorded Frank Mueller, age 16, the son of Joseph and Mary Mueller, as born in Bosnia. The 1930 Census lists Sophiony Balaban, a widowed 50-year-old man, as living in St. Louis. He had emigrated from Bosnia in 1907. There may well have been others from Bosnia and Herzegovina in St. Louis who would have listed their nationality as Serbian or Croatian, as Bosnian Christians often did.

The next round of Bosnian immigrants to St. Louis were anti-Communist political opponents of Yugoslavia. About them, much more is known. In 1923, at age 11, Stipo Prajz left his hometown of Kotor Varoš in northwestern Bosnia to study for the priesthood at the Catholic seminary in Livno. While there, Prajz made a promise to God that if he abandoned the priesthood to marry and have a family, he would, in exchange, commit himself to a life of service for others. Decades later, when the first Bosnian refugees from Kotor Varoš arrived in St. Louis, Prajz felt an instant kinship with them—and an obligation to help.

Prajz arrived in St. Louis in July 1951. "I raised a family. I worked hard. If people would come from Yugoslavia, I'd help them out as much as I could," he said. When fellow Bosnian Smajo Čehajić, a man of Muslim ancestry, came to St. Louis from Cleveland, Prajz helped him get the one available job he knew

[6] "Bosnia: A Land of Romance, of High Sounding Phrases, and of Strange Traditions," *St. Louis Post-Dispatch,* September 10, 1899.

[7] *100 Years of History in Celebration of Our Centennial Anniversary.* Serbian Easter Orthodox Church-School Parish "Holy Trinity" of St. Louis, Missouri, November 2009.

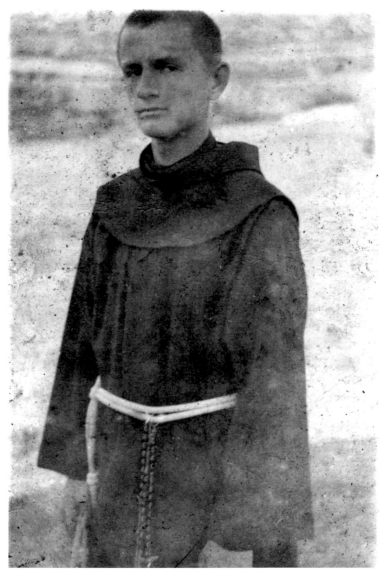

Stipo Prajz as a 17-year-old seminarian in Livno, Bosnia and Herzegovina, 1939. Photo courtesy of Mike Price.

of, in preference to two recent Croatian arrivals from Dalmatia. "Frankly, I had more in common with him," Prajz recalled. "Smajo kept that same job for decades." On the complex question of Bosnian identity, he noted, "At that time, there was no Muslim or Bosniak nationality. You were either Croat or Serb. Many Bosnian Muslims considered themselves Croatians at that time." [8]

Muharem Bašić made St. Louis his new home in 1968. He was a man of mixed religious background: His father was a Bosnian Muslim and his mother a Catholic Slovene, but he thought of himself as Croatian for political and cultural reasons. During the Bosnian war and genocide, Bašić renounced his former affiliation as Croatian and embraced a Bosnian Muslim (or "Bosniak") identity.

Bašić was a restless young man. He was born in 1941, during World War II and the three-way civil war in Yugoslavia among Tito's Communist Partisans; Serbian Royalist Četniks; and the Nazi-aligned Croatian Fascist Ustaše, whose affiliated Home Guard (*Domobrani*) included Muslims like his father. The Home Guard were the regular armed forces of the Independent State of Croatia (*Nezavisna Država Hrvatska*, or NDH) that included conscripts from the Royal Yugoslav Army, while the Ustaše were fanatical paramilitary forces committed to a goal of ethnic "purity" who carried out the extermination of Serbs, Jews, Roma, and others.

After Tito's partisans established the Socialist Federal Republic of Yugoslavia and assumed power, Bašić's father would pay a high price for his wartime affiliation with the Home Guard.[9] Even 60 years later, Bašić recalled with bitterness the 10-year prison sentence his father was handed. "I'm probably the way I am because of my early life without my father," he said. Toward the end of his father's sentence, Bašić was sent to the Bosnian capital of Sarajevo to meet his father's new wife and their children, even though his parents had never officially divorced. "My mother wasn't that surprised. My father did things his own way," he said.

Even as a young man, Bašić firmly rejected Communist ideology and refused to join the Yugoslav Communist Party. He had no interest in or intention of making peace with a Yugoslavia that had taken his father away and broken his family apart. He cultivated his anti-Communist impulses just long enough to plan an escape from his homeland.

In the early morning hours of a warm mid-September day in 1961, a forged passport in tow, Bašić and two friends secured themselves to the undercarriage of a train leaving Maribor, Slovenia, bound for Graz, Austria. Afraid of being caught by the border patrol or the Yugoslavia State Security Service, the three young men held on for their lives as the train traveled 44 miles to Graz.

[8] By 1963, Muslims were listed in the Bosnian constitution alongside Serbs and Croats. The 1974 constitution stipulated equal rights among all nationalities in the territory.

[9] The Socialist Federal Republic of Yugoslavia included Bosnia and Herzegovina, Croatia, Macedonia, Montenegro, Serbia, and Slovenia.

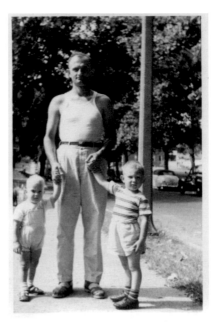

Stipo Prajz with his sons, Steve and Mike, in St. Louis in the 1950s. Photo courtesy of Mike Price.

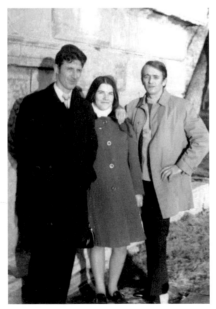

Muharem Bašić, Safija Dedić, and Smajo Čehajić, around 1970. They were among the small number of Bosnians living in St. Louis at that time. Photo courtesy of Safija Dedić Poturković.

After they arrived in Austria, they intended to travel to Salzburg, then cross over into Germany a few days later. The daring trio headed to a local tavern, where they met a man who agreed to help them across the Austrian border. The group arranged to meet in the early morning, drive to Salzburg, then proceed to the German border. But the three were arrested shortly after they arrived at the meeting place, apparently betrayed. The transit to Germany, which was supposed to take just a day or two, instead resulted in eight months' detention.

Bašić's two friends were deported back to Yugoslavia while he was eventually granted political asylum: He convinced officials that his life was in imminent danger if he was returned to his homeland. Bašić was given a choice to stay in Austria or go to a destination of his choice, so he went to Germany to live and work among a growing community of Yugoslav expatriates.

The Yugoslav government opened its borders in the mid-1960s and allowed some of its citizens to find work in Western Europe. Like Bašić, thousands went to Germany, but agents of the Yugoslav secret police followed to infiltrate these émigré communities. Realizing that he might now be in danger because of his activities with Croatian nationalist groups in Germany, Bašić reached out to contacts he had in the United States who agreed to help him get to Cleveland. He arrived on September 20, 1967.

In Cleveland, Bašić found established communities of Bosnians and Croatians, among them Hilmo Bukalo and Smajo Čehajić. Bukalo knew Croatians in Cleveland, St. Louis, and other cities throughout the United States. Bašić and Čehajić joined Bukalo on a trip to St. Louis, where he had many Croatian friends. Bašić and Čehajić were told they could easily find jobs and apartments in St. Louis and were encouraged to relocate.

Bašić and Čehajić moved to St. Louis at the beginning of 1968. Bašić soon became close to members of the Croatian community with whom he shared political views. He even considered himself a Croatian of the Islamic faith.[10] Although Muslim, he regularly attended functions at St. Joseph Croatian Catholic Church in Soulard, only breaking with his Croatian identity and affiliations when war came to Bosnia and Herzegovina in the 1990s. "At that time, there was no International Institute to give you any help, so you were on your own," he said. "There were a lot of other immigrants living in St. Louis at that time—Poles, Germans, and Italians."

[10] Until 1974, Muslims in Yugoslavia could only officially identify as Croat, Serb, or Yugoslav; there was no option for Muslim or Bosniak nationality.

Ibrišim Dedić as a teenager in his hometown of Ključ, Bosnia and Herzegovina, in the 1950s. Photo courtesy of Safija Dedić Poturković.

Ibrišim Dedić during his military service in the Yugoslav National Army in the 1960s. Photo courtesy of Safija Dedić Poturković.

Suljo Grbić in St. Louis in the late 1970s. Photo courtesy of the Grbić family.

Ermina and Suljo Grbić with their daughter Erna in the 1980s. Photo courtesy of the Grbić family.

"We are a very adjustable people, and you adjust to the circumstances. If the circumstances require it, we can be as strong as steel."

— MUHAREM BAŠIĆ

The Community Expands

There were only a few Bosnians living in St. Louis when Ibrišim "Ibro" Dedić arrived in early 1982 at age 24, 10 years before the start of the war and genocide in Bosnia and Herzegovina.

Suljo Grbić came to St. Louis in 1974. He returned to Bosnia in 1981 to marry his wife, Ermina. Their three children were born in St. Louis. Suljo and Ermina were at the center of efforts to help newly arriving Bosnian refugees in the 1990s. (The family would later open south city's popular Grbić Restaurant and Banquet Center.)

Muharem Bašić and Smajo Čehajić were already living in St. Louis, and at that time Čehajić was married to Dedić's sister, Safija, who sponsored Ibro Dedić's relocation. Dedić brought his wife, Esma, and their children, Taib and Safija. The small community of Bosnians was interconnected as family and friends. They socialized, spent time together, and celebrated birthdays as a group.

Dedić landed a job at the Biltwell Clothing factory, where he worked for the next 16 years. He picked up English by playing soccer and refereeing at the Concord Soccer Club in south St. Louis County. He returned to his hometown of Ključ only once, in 1986, for his father's funeral. In 1993, Dedić became one of the founding figures of St. Louis's large Bosnian refugee community. In February of that year he sponsored the first five families to relocate to St. Louis as war refugees.

In addition to Bosnian Muslims, Bosnian Catholics had also settled in St. Louis. Danijela Borić, born in St. Louis before the war and surrounded by a close-knit community of Croatian and Bosnian friends, did not venture much outside of this small circle of South Slavic immigrants in St. Louis in the 1970s. "My parents didn't want me to wear short skirts like the American girls," she recalled. Borić's parents, Nick and Ružica Marjanović, had come from the Bosnian towns of Visoko and Lepenica, in what was then Yugoslavia.

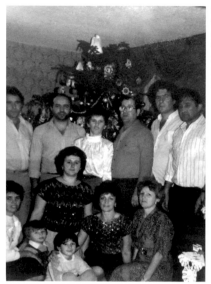

Bosnian families in St. Louis celebrate the holidays together in the late 1980s. Top row: Muharem, Ibro, and Esma Dedić; Remzo Islamović; Suljo Grbić; and Vlado Kireta. Middle row: Nura Dedić, Ermina Grbić, Zilha Kireta, and Mejra Islamović. Bottom row: Ermin and Erna Grbić, children of Suljo and Ermina. Photo courtesy of Safija Dedić Poturković.

Danijela Borić as a child. Photo courtesy of the Marjanović family.

Danijela Borić celebrating Christmas with family and friends in St. Louis. Photo courtesy of the Marjanović family.

Sponsored by their relative Josip Rukčić, the Marjanovićs settled among a network of families from Bosnia and Herzegovina. Within the community of Croatians and Bosnian Catholics who worshipped and socialized at St. Joseph Croatian Catholic Church, there was an expectation of developing an exclusively Croatian identity. "After the war started, my fellow parishioners were forcefully pushing us to turn away from Bosnia. The majority of them were from Bosnia," Borić said, "but now they looked down on Bosnia as enemies. 'Bosnia' meant 'Muslim.' 'Croatia' meant 'Catholic.'"

Borić had been shaped by the summers she'd spent in Bosnia and Herzegovina, and over time, she began to identify as a Croat from Bosnia. "I spent my teenage years in Bosnia. I fell in love there. I walked the *korzo* [boardwalk] there. I felt like a Bosnian girl," she said. "My mother made sure I could speak, read, and write in Croatian, so I was comfortable with the language, which is similar and mutually understandable to Bosnian. Our priests at the Croatian church in St. Louis were true priests, living a life of dedication to the people. Father Joe Abramović and Father Ivo Sivrić—they were Franciscan priests originally from Bosnia and Herzegovina."

She continued, "When we visited Bosnia before the war, the Yugoslav State Security would routinely summon my parents for interrogation about any political activities back in St. Louis. I call them 'the men in black.' They were from the *Tajna Služba*, the Secret Service. I knew they respected my father because when we saw the same men in town, they would greet him warmly and offer to buy him a drink. We suspected there were informers within the community in St. Louis, but we never knew for sure. My parents were American citizens, but that did not stop the Yugoslav authorities from trying to intimidate them. We heard stories about them slapping people around during these interviews.

"Once, when the men in black came to our house in Bosnia to take my parents for questioning, my father said, 'Let's get this over with here.' I was 10 years old, and I tried to intervene by telling them that my parents were American citizens. They thought it was funny, but the harassment really bothered my dad."

Borić went on, "During the war, I traveled to Sweden to visit a friend from Bosnia who had come to St. Louis as a refugee. He had been in a serious car accident here and went to Sweden to see his parents and brother, who had been expelled from Prijedor. His father had been in a concentration camp. When I was in Sweden, I couldn't stand the idea of being that close to Bosnia and not going there. I contacted my cousin to take me there. We crossed the border clandestinely. I couldn't believe the level of destruction I saw there."

The seeds of the small Bosnian community were now planted. Ultimately, tens of thousands of Bosnians would come to St. Louis, fleeing Europe's worst violence since the end of World War II. The Bosnians already settled here would play an important role in helping the newest Bosnian refugees find a place to call home.

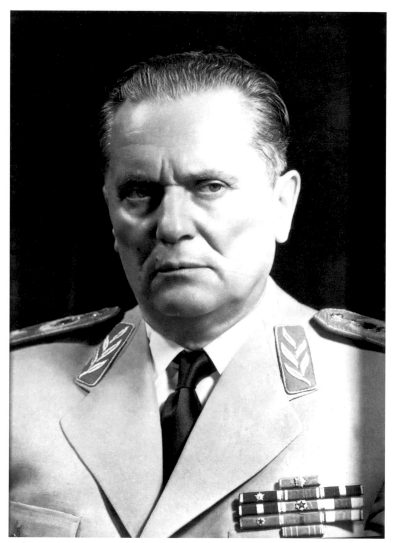

Josip Broz, "Tito," president of the Socialist Federal Republic of Yugoslavia. Photo courtesy of the Digital Library of Slovenia.

CHAPTER 2

YUGOSLAVIA, BEFORE AND AFTER TITO

Yugoslavia once occupied a special place in the world's political geography. Sandwiched between East and West—the Soviet Union with its satellite states, and Western Europe and its allies—the Socialist Federal Republic of Yugoslavia under Tito found an alternate "third way" in the binary Cold War division that would court and placate both sides.

Tito's version of Communism bore little resemblance to its Soviet and Chinese counterparts. Self-managed Yugoslav enterprises were owned by citizen-workers. Yugoslavs were relatively free to travel during the Cold War.[ll] They were not part of the international Communist world after Tito broke with Stalin in 1948.

With Tito's death in 1980, the implosion of Soviet Communism, and the fall of the Berlin Wall in 1989, Yugoslavia's place in the geopolitical calculus began to change. From the outside, Western nations became less interested in Yugoslavia, as it was no longer a buffer against the Soviet Union. Internally, an earlier process of decentralization had given the federation of Yugoslav republics—Bosnia and Herzegovina, Croatia, Macedonia, Montenegro, Serbia, and Slovenia, along with the two regions of Kosovo and Vojvodina—greater autonomy. The means of authority now shifted from the Yugoslav League of Communists to the individual republic's leaders, who had recognized

[ll] They traveled both east and west. Visas were required only for six countries: China, Greece, Israel, West Germany, Albania, and the United States.

the power of stirring nationalist sentiments that had been suppressed in Tito's Yugoslavia.

The ideology of ethnonationalism—which defined national groups based on a shared ethnic heritage, religion, and language—started to resonate across Yugoslavia's separate territorial boundaries. Nationalist politicians, most of whom were former members of the Communist Party of Yugoslavia, identified ethnonationalism as the new basis for political power.[12]

Croatia's first president, Franjo Tuđman, appealed to a long-held dream of Croatian independence that highlighted a common Roman Catholic heritage. He resurrected some of the symbols of the Second World War Nazi puppet government of the Ustaše, which stoked fear among Christian Orthodox Serbs living in Croatia. Croatia's Serbs had been subjected to a genocide during the 1941–1945 Fascist Independent State of Croatia, which then controlled most of Croatia and Bosnia and Herzegovina, as well as parts of Serbia and Slovenia.

In 1989, Serbian president Slobodan Milošević spoke to a gathering of more than 1 million Serbs in Kosovo Polje, where he incited them with predictions of imminent battles, both philosophical and physical, and invoked the historic Serbian defeat at the hands of the Ottoman Turks at that very place 600 years earlier.

When Yugoslavia began to fully unravel in 1991, the Titoist motto of brotherhood and unity—*Bratsvo i Jedinstvo*—was turned on its head, driven in large part by Slobodan Milošević's fiery rhetoric and territorial ambitions. Whereas Tito had retained power in Yugoslavia by *avoiding* ethnic conflicts, Milošević now sought power by *exploiting* ethnic division. By fomenting longstanding grievances among Serbs, Milošević set about to create a Greater Serbia from what had been Yugoslavia, including large parts of Croatia and Bosnia and Herzegovina.

As nationalist movements sprang up throughout Yugoslavia, people in Bosnia and Herzegovina—the most ethnically mixed of the six former Yugoslav republics—watched as Croatia and Slovenia declared independence from Yugoslavia in 1991. A violent response from the federal Yugoslav National Army (JNA) quickly followed. Bosnia and Herzegovina faced the difficult choice of remaining within what was left of Yugoslavia, now dominated by nationalist Serbs, or steering a course toward independence that was almost certain to trigger a response from the JNA.

Despite its many accomplishments in raising standards of living, providing universal healthcare, giving access to higher education, and elevating the place of women in South Slavic society, historical revisionists began to paint

[12] The non-Communist exception was Alija Izetbegović, the president of Bosnia and Herzegovina, who was imprisoned in 1983 for "nationalist offenses hostile to the Yugoslav state." He was pardoned and released after serving five years.

the Yugoslav Socialist project as naive and unworkable. Political repression within Tito's Yugoslavia had been relatively mild compared to its global counterparts. The fundamental weakness of the Yugoslav state was its lack of an effective mechanism for succession and governance after Tito died—a flaw magnified and exploited by ethnic nationalists who were seeking the levers of political power.

As nationalist groups began to rise and political reforms gave way to greater democratic processes and the inclusion of non-Communist parties in the electoral process, non-nationalist civic parties struggled to overcome their perceived connection with the Communist past. These non-nationalist parties sought to preserve a multiethnic Yugoslav state while navigating the economic system toward greater participation in market economies.[13]

The new nationalist parties in Bosnia and Herzegovina entered into a coalition of understanding that helped ensure their success in national elections in he early 1990s. Serbian nationalist, Croatian nationalist, and Bosniak nationalist parties now dominated the political landscape. Paradoxically, this set them on a collision course of irreconcilable differences that left little space for political and social compromise.

An Independent Bosnia and Herzegovina
In a referendum supervised by the European Community (which was later absorbed into the European Union) in March 1992, Bosnian citizens went to the polls and voted overwhelmingly for independence from Yugoslavia. Bosnian Serbs, who made up more than one-third of the population, largely boycotted the vote at the urging of their political leadership.

In early April 1992, in a newly independent Bosnia and Herzegovina, tens of thousands of Bosnians of all backgrounds took to the streets of the capital city Sarajevo, carrying portraits of Tito as expressions of unity and appealing for a peaceful resolution to the mounting Bosnian crisis. They were met with violence instigated by nationalist Serbs who had positioned themselves on the upper floors of Sarajevo's Holiday Inn hotel. The Bosnian demonstrators were fired on, and Suada Dilberović and Olga Sučić were killed. These two women were among the first victims of the war and genocide in Bosnia and Herzegovina.

The war that followed was designed to separate the Bosnian people by force, uproot them from their homes, and permanently displace them. This was not a spontaneous consequence of ethnic tensions suddenly boiling over: Ethnic division was not a cause but rather an effect of the war. The explanation that

[13] In many ways, Yugoslavia was ideally positioned to make the transition to a democratic state with a market economy. Ironically, the former Soviet bloc countries of Czechoslovakia, Hungary, and Bulgaria were more successful based, in part, on the negative example of the destructive nationalist path in Yugoslavia.

the war and genocide were the result of age-old blood feuds is a falsehood that persists even today. But in reality nationalist aggressors wanted to expand the territory of Serbia and Croatia into parts of Bosnia and Herzegovina.

In May 1992 the self-declared Bosnian Serb Assembly, under the political leadership of Radovan Karadžić, announced six strategic objectives for the Serbian people of Bosnia and Herzegovina[14]:

- Separate the Serbian people from the other two major ethnic communities.

- Create a territorial corridor to link the Serbian communities in the eastern and western parts of Bosnia.

- Eliminate the Drina River as a border between areas in eastern Bosnia under Serb control and Serbia itself.

- Set a border for the Serbian Republic (*Republika Srpska*) on the Una and Neretva rivers.

- Divide the city of Sarajevo into Serb and non-Serb areas.

- Establish access to the sea for the Serbian Republic.

These demographic and geographic objectives formed the basis of most of the war's military operations. Approximately 70,000 Serb volunteers were armed by both the Yugoslav National Army and the major Bosnian Serb political party in municipalities all over Bosnia to prepare for the forcible takeover of designated territory.

Beginning in March 1992 and continuing over the next three and a half years, the Bosnian Serbs effectively achieved their strategic objectives (other than the relatively insignificant goal of direct sea access). Each one stemmed from the primary objective—to divide the Bosnian people. An organized and comprehensive campaign of genocidal violence was launched throughout Bosnia and Herzegovina, where Serb paramilitary forces crossed the Drina River and entered the city of Bijeljina in eastern Bosnia.

During the second week of April the focus remained on the Drina Valley, in places such as Visegrad and Foča, and then south to Zvornik. In the third week takeovers continued along the Drina River border, and Bratunac came under Serb control. During the fourth week Serb control pushed into western Bosnia in Mrkonjić Grad and into large parts of Bosanska Krupa, bringing the

[14] Hikmet Karčić, "Blueprint for Genocide: The Destruction of Muslims in Eastern Bosnia," *Open Democracy*, May 11, 2015.

border of Serb-controlled lands to the banks of the Una River. The campaign in the Drina Valley continued with the takeover of Vlasenica. By the end of April, 35 municipalities would be under Serb control—an average of over one municipality per day.

In the early morning of April 30, 1992, extreme nationalist Serbs carried out a small-scale coup d'état against the elected government in Prijedor, and Serbian flags were placed on all of the town's official buildings. Sandbag shelters were erected for soldiers, who were armed with automatic weapons and positioned at all the main intersections, in front of banks and other important buildings. Snipers were on rooftops.[15]

Over Radio Prijedor, Serb authorities demanded that the Muslims and Croats living in areas with mixed ethnic populations of Serbs and non-Serbs were to mark their homes by hanging out a white flag and wearing a white armband as signs of surrender. From this point on the Bosnian Serb Army, with the Bosnian Serb police, would solidify the gains of the initial offensive and systematically realize their most important strategic objective of separating citizens by ethnicity.

In 1991, the year before the Bosnian war, Prijedor's population of 112,541 was made up of almost equal numbers of Muslims and Orthodox Christian Serbs (at 44 percent and 42 percent, respectively). About 5 percent considered themselves Roman Catholic Croats, another 5 percent called themselves Yugoslavs, and the roughly 3,000 who remained were other nationalities.[16]

In Prijedor and other places Serbs targeted for "ethnic cleansing," there were more Muslim citizens than Serbian Orthodox ones. "The fact that Muslims are the majority makes no difference," announced Bosnian Serb president Radovan Karadžić. "They won't decide our fate."[17] The Serbian project of conquest now had its sights set on any land where Serbs lived—whether they were in the majority or not—and without regard to any other inhabitants.

Major bombardments of non-Serb areas in Prijedor followed. Members of the Bosnian Serb Army perpetrated serious crimes, including massacres in Sanski Most. Serb authorities tried to portray their victims as terrorists or link them with past crimes, calling the Muslims *Mujahedeen*, which conjured images of Islamic jihadists, while referring to the Catholics as *Ustaše*, the ultranationalist Croats who allied with the Nazis during World War II.

[15] Final report of the United Nations Commission of Experts established pursuant to Security Council Resolution 780 (1992). *Annex V: The Prijedor Report*. Prepared by Hanne Sophie Greve, Member and Rapporteur on the Prijedor Project, Commission of Experts Established Pursuant to Security Council Resolution 780 (1992).

[16] Ibid.

[17] *Frontline*, "The Horrors of a Camp Called Omarska," written by Mark Danner, aired spring 1998 on PBS.

Concentration camps were established in Omarska and Trnopolje. On the other side of the country, camps were opened in Vlasenica, Rogatica, Ilidža, and Foča. The massive bombing of Sarajevo commenced by the end of May 1992. That same month General Ratko Mladić, who had just been made the head of the Bosnian Serb Army, rose to remind his assembled colleagues that "People and peoples are not pawns, nor are they keys in one's pocket that can be shifted from here to there." Mladić said to do so would be tantamount to genocide.[18]

Nationalist Serbs began attacks against Bosnia and Herzegovina, first using paramilitary forces and later the full power of Yugoslav National Army. Under a United Nations arms embargo and without an organized army of its own,[19] Bosnia quickly lost more than two-thirds of its territory. Sarajevo was encircled by Serb forces who lay siege to the capital city's civilian population.

When the war began, commentators repeated easy assumptions that age-old tensions over national identity were to blame, and no outside force could alter events that were now on an inevitable course toward ethnic warfare. The international community quickly adopted this narrative too as it perfectly suited their lack of desire to become entangled in what they perceived as a complicated Balkan conflict. Ordinary Bosnians would pay the highest price for this policy of malignant neglect.

Meanwhile, most Bosnian people had not yet embraced these new realities. They were accustomed to the strong social relationships that had been forged over generations; close friendships and marriages among people from different ethnic-national groups were commonplace. Many Bosnians vowed and maintained a courageous commitment to a pluralistic society throughout the war and genocide over the next three and a half years.

Still, extreme nationalists worked to change the hearts and minds of Bosnian citizens from a place of interdependence and unity to one of bitter antagonism and division. As part of the systemic "ethnic cleansing" of Bosnia and Herzegovina, ordinary citizens were now subjected to violence and degradation, including rape and sexual assault, torture, and the destruction of the social infrastructure that had sustained their intercommunal life. Mosques, churches,

[18] The International Criminal Tribunal (ICTY), *The Prosecutor v. Ratko Mladić*, https://icty.org/x/cases/mladic/trans/en/120516IT.htm.

[19] On September 21, 1991, the United Nations Security Council passed resolution 713, imposing an international arms embargo on all Yugoslav territories, with the aim of preventing the escalation of violence. The embargo overlooked that the Yugoslav National Army was the only fully equipped force in Yugoslavia, and its stockpiles of ammunition and weapons were under full Serb control. Bosnia and Herzegovina was left to defend itself with what had either been captured in battles or smuggled into the country under extremely difficult conditions. The arms embargo cemented this imbalance, forcing Bosnia to make repeated calls to lift the embargo so that the country could defend itself. The embargo was viewed as an illegal violation of the Bosnian right to self-defense under Article 51 of the UN charter.

schools, hospitals, museums, libraries, and homes were deliberately targeted. The attacks brought a level of brutality well beyond any normal military objective. The point was to so utterly terrorize people that they would never want to return to the homes they were being expelled from.

In St. Louis, Ibro Dedić and his Bosnian friends and relatives watched in horror as the war in Bosnia and Herzegovina unfolded. Dedić thought of himself as a Yugoslav and couldn't believe that neighbor had seemingly turned against neighbor so abruptly. His youngest brother, Refik, had been captured by Serbian forces near their hometown of Ključ, then sent to Bosanska Gradiška, and later to the Manjača concentration camp, as Serbs swept through towns and villages, targeting their Muslim and Catholic populations.

Many Serbs lived in an area of western Bosnia known as the Krajina. Bosnian Serb leaders recognized that if this population were to become a viable part of a Bosnian Serb state, it had to be physically connected to it. With this objective in mind, five Bosnian municipalities were attacked: Prijedor, Sanski Most, Banja Luka, Kotor Varoš, and the Dedićs' hometown of Ključ. Many of the first Bosnians to come to St. Louis were from one of these municipalities.[20]

Journalist Mark Danner described what happened next: Serb military forces surrounded these areas and, after warning resident Serbs, began artillery attacks and random executions to draw people out of their homes. Political leaders and the educated elite were murdered. Women and children were separated from men of "fighting age," defined as young as 16 and as old as 60. These women, children, and the oldest men were expelled to neighboring territories or deported to other countries. Men of fighting age were executed, their bodies disposed of.[21]

"I couldn't believe my eyes when I saw what was happening," Dedić recalled. "That normal people could do that to one another. The food was stuck in my throat when I saw those pictures on television."

In the systematic campaign of deportation and murder, 52,811 Bosnian Muslims and Bosnian Catholics—nearly 47 percent of the city's population—were expelled from Prijedor. Among the 3,173 murdered (or disappeared and presumed dead) in Prijedor, 102 of them were children.

A Bosnian American Comes Home to St. Louis

In the spring of 1992, Aida Bašić, 14 years old and born in St. Louis to Bosnian parents, was growing up amid the siege of Sarajevo. Her mother, Safeta Ovčina, left St. Louis after her divorce when Aida was 2. She and Aida were suddenly in the middle of the war in Bosnia and Herzegovina. Safeta was a nurse at Koševo Hospital in Sarajevo, where most of the city's wounded and dying were being brought.

[20] The International Criminal Tribunal (ICTY), *The Prosecutor v. Radovan Karadžić*. Amended Indictment, para. 17 (2000), http://www.icty.org/case/karadzic/4.

[21] Mark Danner, "Endgame in Kosovo," *New York Review of Books* 46, no. 8 (May 6, 1999).

Safeta Ovčina in the 1990s. She was a key
advocate for US action in Bosnia and
Herzegovina. Ovčina escaped from Sarajevo
with her daughter Aida at the end of 1992.
Photo courtesy of Safeta Ovčina.

July 27, 1993

Ms. Saleta Gucina
4940 Viento
Saint Louis, Missouri 63129

Dear Saleta:

 I appreciate hearing your views on the situation in the
former Yugoslavia. I am deeply concerned about the continuing
aggression there and the atrocities that are still being
inflicted upon the people of that region.

 I am working closely with my foreign policy team to help
resolve the problems that have caused this conflict. Bringing
peace and stability to that area of the world is one of my
Administration's highest priorities. We face many tough
choices in dealing with the tragedy in Bosnia, but it remains
my intention to work with our allies on a course that will help
repair the damage that this conflict has done to the Balkans
and to Europe.

 Thank you for your interest in this important issue.

Sincerely,

Bill Clinton

1993 letter from President Bill Clinton to Safeta Ovcina. The war
continued until the fall of 1995 when Clinton's foreign policy team
brokered the Dayton Peace Agreement ending the Bosnian war.

Aida and Safeta were found in Sarajevo by Joel Brand, a *Newsweek* journalist who was on a mission to locate and help evacuate American citizens trapped in Bosnia and Herzegovina. Brand found out that Aida was a US citizen by birth, and he decided to look for her and offer both her and Safeta safe passage to the United States.

At first, Safeta rejected the idea. She was determined to stay with her family in Sarajevo and help at the hospital as much as she could. But out of concern for Aida, Safeta decided to leave. With assistance from the US Embassy in Sarajevo, Aida and Safeta were airlifted from the besieged city on Christmas Day. They spent a few days in Zagreb, Croatia, before arriving in St. Louis on January 7, 1993.

"I vividly remember leaving Sarajevo in December of 1992," Aida recalled. "People said at the time that not even a bird could flee out of the city. The Serbian Army occupied the nearby mountains, and the city was bombed and shelled on a daily basis."

In St. Louis, Aida and Safeta became the human faces of the Bosnian war. *St. Louis Post-Dispatch* reporter Christine Bertelson wrote sympathetic portraits of Safeta and Aida and encouraged Safeta to pen an op-ed. In June 1993, Safeta wrote:

> I am ashamed because I left Sarajevo. Every bite of food or smile here reminds me of the hunger and sadness of my people. It is sad because the Serbs and the United Nations are not ashamed of this holocaust and further dividing of people. The United Nations falsely reports to the world that this is a civil or ethnic war and how people have a long-standing hatred for one another.

After only a short time back in the United States, Safeta had become a fierce advocate for Bosnia and Herzegovina, testifying before the US Congress and writing in the same *Post-Dispatch* op-ed:

> Since coming here, I spend all of my energy telling the good American people, with their democratic government, the truth about the war in Bosnia and Herzegovina. I hope they will not follow some members of Congress, who, because of personal interests, refuse to vote to lift the arms embargo.
>
> The Bosnian people must be allowed to defend themselves and their children. They want a free, democratic country with equal rights for all people, without regard to nationality, faith or skin color, like you have in the United States.
>
> I wanted you to know that the eyes of all of the people of Bosnia and Herzegovina are turned to you in hope of your help. Don't be a passive observer or unwilling participant in the dirtiest war in history. This is a war against unarmed and innocent civilians.

St. Louis answered the urgent call for refugee assistance. The International Institute of St. Louis, the largest such agency in town, had been monitoring the refugee crisis in Bosnia. Sarah Leung, in charge of refugee resettlement for the organization, contacted Ibro Dedić to ask about the logistical and language help that would be essential in bringing Bosnian refugees to St. Louis. Dedić readily stepped up.

Initial Arrivals

At the beginning of 1993, Leung asked Dedić to sign sponsorship papers for the first five refugee families coming to St. Louis. They included Alma and Jasmin Hadžić (pseudonyms to protect their identities), Reuf Travančić, Velid Kuželj, Halid Denić, and Šerif Softić, who all arrived together in St. Louis in February 1993. Many of the Bosnians already living in St. Louis went to the airport to greet the families. Ermina Grbić remembers trying to make them feel welcome, wanting to give them some sense of the familiar. "I would cook all morning to make fresh food and bread, and then I would go to work so that the families would have our food," she said.

"They were really lost and confused and, in some cases, afraid to go out," Ermina continued. "[Alma and Jasmin Hadžić] had been imprisoned in the Omarska concentration camp, and they didn't want to touch anything in their apartment because everything was so dirty. They were afraid they would get sick because they were in such a weakened state."

The Grbić family hosted a number of new refugees. "We sometimes had 20 people sleeping at our place. We felt like we didn't really have a choice. This was war. People lost so much. They were our people. We had to do what we could to help," Ermina recalled. Her husband, Suljo, added, "We didn't think about it too much. We just did what we could." He had never before been political and distrusted all politicians.

The International Institute's Leung suggested to Dedić that the new Bosnian families could be placed in apartments close to the institute, located in midtown near Cardinal Glennon Children's Hospital and Saint Louis University School of Medicine. But Dedić was worried about the safety of that area and instead found the families apartments along Compton Avenue and on Winnebago and Minnesota streets on the city's south side—neighborhoods that would fill with Bosnians in the years to come.

Anna Crosslin clearly remembers the first Bosnians who arrived as war refugees. As the president and CEO of the International Institute of St. Louis, she presided over one of the nation's most significant relocations of deported Bosnians—the largest concentration anywhere in the world outside of Bosnia and Herzegovina.

"The first Bosnian families who came did not have family sponsors in the United States," Crosslin recalled. She submitted a report to the US Department of State that demonstrated that St. Louis had sufficient capacity and

infrastructure, such as available low-cost housing, access to employment, and basic public transportation.

"We worked through St. Joseph Croatian Catholic Church to identify Bosnians already in the area who could assist with initial resettlement," Crosslin said. "From that nucleus, the community continued to grow as more and more refugee families arrived, sponsored through an official government certification and forms called an Affidavit of Relationship."[22]

Refugees were welcomed at St. Joseph Croatian Catholic Church in Soulard. They were brought to the church hall, where Stipo Prajz passed a hat to collect cash donations. In the days that followed, St. Joseph parishioners took some of the new arrivals to their own physicians and dentists, as the refugees were in poor physical shape.

Parishioners including Judy and Dan Ryan, Janet Deranja, Sofija Pekić, and Judy Feldworth provided steadfast help over the next several years to the first waves of Bosnian refugees. Among them was Reuf Travančić, who had been a police investigator in his hometown of Prijedor. He had spent eight months in Serbian-run concentration camps, where he was badly beaten.[23] Travančić came to St. Louis with his teenage son, Elvis.

"When we arrived in St. Louis, we were driven to our apartment furnished with two old mattresses on the floor and a set of plastic silverware," Travančić told the *Post-Dispatch* in an interview. "As the person who brought us here was leaving, he told us not to walk outside at night and always to keep the doors locked. We were in shock and scared.

"It was difficult," Travančić went on. "But when I got my first job, I felt that the American people welcomed me and made me believe in a future here."[24]

[22] Interview with the authors, June 21, 2014.

[23] Trial testimony by fellow inmates at the International Criminal Tribunal for the former Yugoslavia described seeing Travančić nearly unconscious and his body black and blue from beatings in the Omarska camp.

[24] Dijana Groth, "A Haven from Horror: Bosnians Who Have Nowhere Else to Go Have Found Homes Here," *St. Louis Post-Dispatch*, November 21, 1994.

CHAPTER 3

OUT OF THE INFERNO

In the early spring of 1993, Jasmin Hadžić looked out his apartment window and surveyed the unfamiliar surroundings. He saw apartment buildings stretching in both directions, similar-looking redbrick rectangles in disrepair. Although cars would occasionally pass by his new home in south St. Louis, no one really knew he was there. Jasmin himself barely knew—and could hardly believe—where he was.[25]

Jasmin and his wife, Alma, were among the first Bosnian refugees who resettled in St. Louis after being released from Bosnian Serb concentration camps and expelled from their home in Prijedor—a city that had been the epicenter of genocidal violence in Bosnia. St. Louis would eventually become home to as many as 60,000 Bosnian refugees, but the Hadžićs were part of a small nucleus of five families around which a larger community would grow.

In late 1992 the US Department of State approved emergency refugee admission for Bosnian concentration camp survivors and their families. They were considered "free cases"—unattached refugees who didn't have relatives or friends in their American host cities. The Hadžićs were sent to St. Louis because the International Institute had been approved to accept a portion of those uprooted by the conflict engulfing Bosnia and Herzegovina.

[25] Pseudonyms are used in this chapter to protect identity.

In the international media, Jasmin's home city of Prijedor had been linked to Serbian nationalists' "ethnic cleansing." Despite the widespread global attention focused on their hometown, the Hadžićs' reception here went mostly unnoticed. Jasmin and his wife spent their first night in St. Louis on mattresses on the floor, using their coats as pillows.

By then the war had already displaced more than 2 million of Bosnia's total population of just over 4 million. Serbian forces now occupied 70 percent of Bosnian territory, leaving tens of thousands of Bosnian civilians dead in the wake of their territorial conquest.

Prijedor: Ground Zero of "Ethnic Cleansing"

Located in northwest Bosnia, Prijedor had a population of around 120,000 before the war. It was a religiously mixed city of Bosniak Muslims, Catholic Croats, Orthodox Christian Serbs, and those who declared themselves Yugoslavs or another national origin.[26] Prijedor was a microcosm of Yugoslavia itself, part of the Socialist-era ideal of people from different backgrounds living, working, and socializing together freely and without noticeable distinction. Up until the war, when "Bosnian" became an adjective—as in Bosnian Muslim, or Bosnian Croat, or Bosnian Serb—the term was a proper noun that referred to all who lived in Bosnia and Herzegovina.

Like most people in Prijedor, Jasmin Hadžić had never paid much attention to the city's religious or ethnic composition. The main Serbian church sat across from the city's old mosque, and the Catholic church was right up the street. Prijedor's Muslims and Christians didn't just tolerate each other—they lived their daily lives together. Indeed, the majority of people in this multiethnic

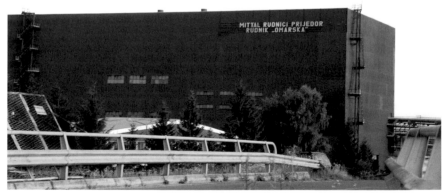

The Omarska iron-ore mining center in 2007. In 1992 it was converted into a wartime concentration camp and killing center.

[26] For a detailed account, see Isabelle Wesselingh and Arnaud Valerin, *Raw Memory: Prijedor, Laboratory of Ethnic Cleansing* (London: Saqi Books, 2005).

city thought of themselves as Bosnians and citizens of Yugoslavia, regardless of their religious or ethnic background. And apart from the Serbian separatist planners, no one had anticipated the sudden, violent takeover of Prijedor. On April 30, 1992, extreme nationalist Serbs in Prijedor announced a self-declared "Crisis Committee" and implemented a military-style coup of the city's government. The democratically elected Bosniak mayor, Muhamed Čehajić, was arrested and placed in the Omarska concentration camp, an improvised prison on the grounds of an iron-ore mining facility. Jasmin Hadžić, along with other prominent members of the non-Serb elite in Prijedor, would soon join him.

Following the Serb decree, Prijedor's non-Serb professionals—doctors, lawyers, politicians, and business owners—were rounded up based on prepared lists. Some were simply executed outright. The intent was to destroy Prijedor's capacity to function by removing those who held leadership positions.[27] The remaining non-Serb population was forced to wear white armbands and fly the white flag of surrender from their homes. Hadžić was caught off-guard by the rapid Serb takeover. In fact, when the siege of Sarajevo had started earlier that same month, he had encouraged his friends to come to Prijedor where, he assured them, everything was safe.

Practically overnight, Serb nationalists implemented their takeover of Prijedor with military precision and efficiency. The city's non-Serbs were dismissed from their jobs while coordinated attacks began on Muslim and Catholic villages in the surrounding area.

Ethnic differences—which previously held little significance—were now at the center of the conflict, resulting in an organized aggression that would quickly envelop all of Bosnia and Herzegovina. With its large population of Bosnian Muslims and Catholics, in 1992 Prijedor became the center of the worst violence Europe had seen since the end of World War II.

US officials, meanwhile, resorted to oversimplifications about Balkan history to obscure their inaction and, ultimately, their indifference to the suffering of Prijedor's non-Serbs, who now faced extermination or expulsion by Serb military forces. This acceptance of Serb aggression was particularly cruel because US policymakers knew from press reports and their own intelligence that the Serb methodology was to intentionally and systematically inflict terror on the civilian population of Prijedor, including by mass executions and rape.

Rather than a collateral effect of Serb policy, the brutal "ethnic cleansing" of Bosnia was itself the objective, and America turned a blind eye in response. In a protest against US policy toward Bosnia, several staff at the Yugoslav desk within the US Department of State resigned.[28]

[27] Ibid.

[28] Mark Matthews, "State Dept. Resignations Reflect Dissent on Bosnia U.S. Policy Called Weak, 'Dangerous,'" *Baltimore Sun*, August 24, 1993.

The Long Night of Terror

On June 7, 1992, Hadžić was arrested by Serb authorities and brought to a former ceramics factory called Keraterm, just outside of Prijedor. Inmates were packed into the Keraterm camp without food, water, toilets, or bedding.

When he arrived at Keraterm, Hadžić recognized one the guards as a man he used to work with. The man asked, "Even you, Jasmin?" in a menacing tone. During interrogation, Hadžić was questioned about favoring non-Serbs at his place of employment, a common pretext for arresting Prijedor's Muslims and Catholics. Most of his close friends had been Serbs, which made the false accusation all the more absurd.

An environment of fear and dread pervaded the Keraterm camp. Prisoners were brutally beaten and tortured. On the night of July 23, 1992, approximately 200 Keraterm prisoners were murdered. Hadžić felt lucky to have survived, but he didn't know that even worse was still to come.

A Place Called Omarska

By first rounding up Prijedor's most influential non-Serb citizens, the Serb nationalists calculated that there was little hope the rest of the city could withstand the takeover. They also knew they needed to terrorize the non-Serb population of Prijedor to such an extent that even those who survived would never want to return. The Serbian objective in Prijedor was to expel or kill the majority of the city's Muslims and Catholics, and then link the "ethnically pure" territory to Serbia proper, creating a long-dreamed-of "Greater Serbia." This was the strategic template for Serb attacks on other Bosnian cities, towns, and villages for the next three and a half years.

On July 7, 1992, Hadžić was transferred from Keraterm to Omarska by bus. From the window, he could see that as prisoners exited the bus they had to pass through a gauntlet of Serb guards who beat the new arrivals with bats and other weapons. His only thought was how to stay alive. When his turn came, he moved as quickly as he could down the line as a torrent of blows battered his body.

Prisoners were led into a small administrative building called the "White House," which was used to torture and kill inmates. Upon entering, they were forced to lie face-down on the floor next to one another in tight rows. Hadžić thought he was sweating, but when he touched his head, he realized it was blood running from a gash in his skull. He had also sustained three broken ribs during the beatings from the bus to the building. That night, an orgy of violence took the lives of dozens of prisoners. Hadžić, who had already been so badly beaten that he couldn't walk, was again spared the fate of so many others around him.

Omarska was used as a killing center, a place to brutalize and humiliate. Its conditions were intentionally barbaric. Overcrowded with little to eat or drink, many prisoners came to resemble walking skeletons. Enduring a daily routine of extreme violence, inmates didn't have the strength to resist. "We won't waste

our bullets on them," an Omarska guard said. "They have no roof. There is sun and rain, cold nights, and beatings two times a day. We give them no food and no water. They will starve like animals."[29]

Prijedor's deposed mayor Čehajić, who had advocated Gandhian-style non-violent resistance to the Serb takeover, was murdered in Omarska on July 16, 1992. Those who survived were starved, beaten, and tortured in unimaginable ways. In one instance, an inmate was forced to bite off the testicles of another prisoner. Between April and August 1992, several hundred prisoners in Omarska died or were killed.

Even in an atmosphere of inescapable sadism, prisoners in Omarska fought to preserve their dignity. When a beloved local physician, Dr. Eso Sadiković—who had provided medical care for both inmates and guards—was called out by his Omarska jailers for execution, fellow inmates rose in unison as a sign of respect as he was led away to his death.[30] That someone as well liked and useful as Sadiković could be murdered only confirmed the deep sense of dread and despair among the prisoners at Omarska.

The World Turns a Blind Eye

President George H. W. Bush initially denounced the existence of Omarska and the other camps discovered in northwest Bosnia in the summer of 1992. But when these revelations were followed by calls for strong US action and intervention, Bush retreated to a position of evasion and ambiguity, citing "all kinds of ancient rivalries."[31]

But the conflict in Bosnia and the takeover of Prijedor were not rooted in ancient ethnic hatreds. They stemmed from the political realities of the present. Bush instead called for Red Cross access to the camps and avoided confronting the Serb aggression that had already risen to genocidal levels.

The year before, President Bush had ordered a US–led coalition of forces to Iraq to reverse Saddam Hussein's invasion of Kuwait. Now the president's advisers, including Secretary of State Lawrence Eagleburger, warned Bush that military action in the former Yugoslavia would result in an unwanted entanglement for the United States.

Citing the "complexities" of the Yugoslav crisis, the official American position was to provide only humanitarian assistance. In practice, it was a contradictory policy of feeding victims while also allowing them to be slaughtered. With mounting public pressure to "do something," the United States made the fatal mistake of appeasing rather than confronting Serb aggressors.

[29] Mark Danner, "America and the Bosnia Genocide," *The New York Review of Books* 44, no. 19 (December 4, 1997), 55–65.

[30] See https://www.icty.org/x/cases/brdanin/trans/en/030113ED.htm.

[31] Norman Kempster, "No Easy Answer to Bosnia Crisis, Bush Stresses," *Los Angeles Times*, August 9, 1992.

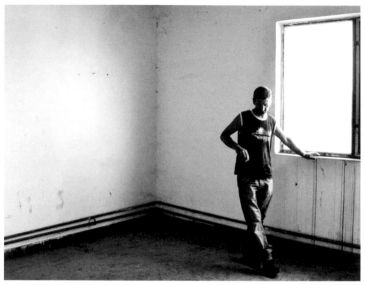

An Omarska survivor in the "White House" during a commemoration event in 2012. Photo courtesy of Claire Noone.

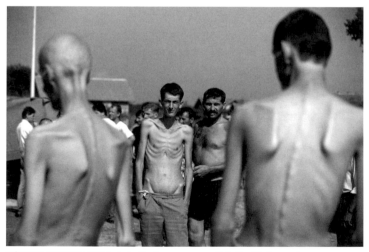

Prisoners at the Trnopolje concentration camp near Prijedor. Photo courtesy of Ron Haviv/VII/Blood and Honey.

Meanwhile, presidential candidate Bill Clinton was campaigning on a Bosnia policy of "lift and strike": lifting the United Nations–imposed embargo on weapons that Bosnians needed to defend themselves and launching airstrikes on besieging Serb forces. Such actions were necessary, candidate Clinton said in 1992, to save Bosnians from "deliberate and systematic extermination based on their ethnic origin."[32]

But like Bush before him, incoming president Clinton quickly reversed his position and invoked rhetoric that made no distinction between the aggressors and their victims. He reverted to clichés about the region, declaring at one point, "Until those folks get tired of killing each other over there, bad things will continue to happen."

Throughout the war, similar stereotypes about "ancient ethnic hatreds" in the Balkans became shorthand for the American government's unwillingness to acknowledge and confront the systematic violence in Bosnia. To gain support for inaction, elected officials summoned the ghosts of Vietnam and warned about a "quagmire" in Bosnia.

When the United States finally became involved three years later, no such quagmire occurred. Following worldwide outrage over the genocide in the former UN Safe Area of Srebrenica—which turned out to be the site of untold numbers of executions and deaths—Bosnian Serb forces were quickly dispatched by a six-week NATO bombing campaign. There was not a single US combat casualty during or after the air attacks. But it was already too late. By then Bosnia had been decimated, its infrastructure destroyed. More than 100,000 were dead, and half of the population were now refugees.

The US–sponsored Dayton Peace Agreement locked in the ethnic divisions and rewarded Serbian genocidal aggression with an "ethnically cleansed" entity called *Republika Srpska* that encompassed just under half of the country, including Prijedor and Srebrenica. American policymakers chose to address the early carnage in Bosnia as a humanitarian problem rather than as a political and military crisis. Serbian forces—later joined by Croatian militaries in the carve-up of Bosnia—rightly understood US policy as a tacit acceptance of their territorial aggression that included a campaign of mass murder.

Along with the United States, the wider international community also treated the legitimate government of Bosnia and Herzegovina as merely one "party" to what would become a three-sided conflict. This undermined the basis and stability (if not the very existence of) a multiethnic, democratically elected, internationally recognized Bosnian government.

Throughout the war, diplomats and the media referred to the multi-religious Bosnian government as the Muslim government, or the "Muslim side," while never labeling its antagonists as Christian forces. This vernacular revealed an

[32] "Bush Urged to Take Action Against Serbs," *Washington Post*, August 6, 1992.

anti-Muslim bias that reinforced the false notion that Bosnia's government was exclusively Muslim.

The UN had applied an arms embargo to all six countries in the former Yugoslavia. This significantly compounded the disadvantage for the Bosnian government's makeshift army while boosting the military advantage of Serbian forces who had access to the former Yugoslav Army's heavy weapons. The new Republic of Bosnia and Herzegovina, a UN Member State, was effectively denied the right of self-defense. Commentators speculated that if the reverse had been true, with Muslims killing Christians in Central Europe, the international response would have been decidedly different. Rather than upholding the celebrated European values of diversity and openness, the governments of the world accepted—and thereby reinforced—the ethnic division of Bosnia and Herzegovina.

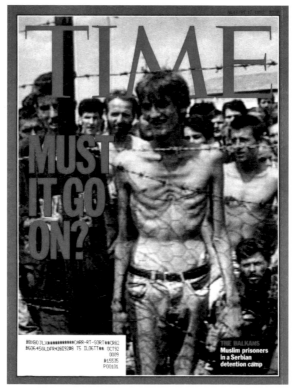

Trnopolje prisoner Fikret Alić on the August 17, 1992, cover of *Time*.

The Final Days of Omarska

When reports began appearing in international media about Omarska and the brutal atrocities committed there, the Bosnian Serb leadership faced intense pressure to allow access to the camp. Bosnian Serb president Radovan Karadžić invited journalists to "see for themselves that Omarska was not a concentration camp" and that conditions were not as bad as what was being alleged.

The journalists, including Ed Vulliamy of the British newspaper the *Guardian*, entered the Omarska camp on August 6, 1992. Although they were only shown the inmates who were in the best physical condition, Vulliamy was still shocked by what he saw. In an article titled "Shame of Camp Omarska," Vulliamy wrote: "The internees are horribly thin, raw-boned: some are almost cadaverous, with skin like parchment folded around their arms, their faces are lantern-jawed, and their eyes are haunted by the empty stare of the prisoner who does not know what will happen to him next."[33]

His story—accompanied by photos of Fikret Alić, a skeletal prisoner held at the nearby Trnopolje camp—and others like it created worldwide outrage that drew parallels to the Holocaust and prompted action from the UN Security Council.

Inside the Omarska camp, there was little awareness that the attention of the world had now turned to Prijedor and Omarska. Just days before the camp was closed, the killing had become so intense that bulldozers were used to load the bodies into dump trucks and move them to mass grave sites. Serb authorities, now desperate to sanitize the reality of Omarska, executed an unknown number of inmates. They hastily transferred the remaining prisoners, including Jasmin Hadžić, to other camps and finally closed Omarska.

Those who ran the Omarska camp would later be indicted by The Hague Tribunal and found guilty of war crimes and crimes against humanity—murder, torture, sexual violence, persecution, and other inhuman acts—as part of a joint criminal enterprise.

Hadžić, now reduced to 120 pounds (his normal weight was around 200 pounds), made his way to St. Louis. For Hadžić and other new refugees, the long shadow of genocide would mark their experiences as the Bosnian community took shape in the strange new city by the great Mississippi River.

[33] Ed Vulliamy, "Shame of Camp Omarska," *The Guardian*, August 7, 1992.

CHAPTER 4

ST. LOUIS RESPONDS TO WAR AND GENOCIDE IN BOSNIA AND HERZEGOVINA

From the beginning of the Bosnian war, the *St. Louis Post-Dispatch* reported on the conflict almost daily. In the Sunday edition of the paper on April 14, 1991, reporter Harry Levins wrote a feature titled "Balkan Powder Keg: Tito Held Yugoslavia Together But It's Not Clear What Else Can." An editorial published earlier that year had warned, "Civil War Is Brewing in the Balkans."

The *Post-Dispatch* published letters to the editor both for and against the breakup of Yugoslavia. One from January 11, 1992, written by Anne Thorton of Kirkwood, asserted, "The peoples of Croatia, Slovenia, Bosnia-Herzegovina, Macedonia, Kosovo and Vojvodina are sick and tired of Communist oppression. They have a right to self-determination to be free. The republics of the former U.S.S.R. are being recognized as independent countries, why don't the republics in former Yugoslavia have that same right?"

The intensification of the Bosnian war and the discovery of concentration camps in northwest Bosnia brought the conflict to the *Post*'s front pages. An August 7, 1992, headline blared, "Bush Seeks Option of Force in Bosnia." Two days later another front-page story declared, "Serb Leader in Bosnia Offers to Dismantle Detention Camps." Elsewhere in the *Post* that day, the stories "Torture Described in Serbian Camps," "Origins of Conflict in Yugoslavia," and "Yugoslav Conflict Called a Potential 'European Vietnam,'" reflected the growing reluctance of the US and its European NATO allies to intervene militarily in Bosnia despite reports of genocidal violence directed at Bosnia's civilian population—some of whom would arrive in St. Louis as refugees within six months.

Letters to the editor in the August 7, 1992, edition included Richmond Heights resident Saul Mirowitz, the St. Louis chapter president of the American Jewish Committee, who wrote: "The cries of anguish of the citizens of Bosnia and Herzegovina cannot be ignored. The United States must exert its leadership and with the European community use whatever means necessary, including military action with the sanction of the United Nations, to end the slaughter, dispossession and devastation and assure temporary haven for refugees."

In the same issue Franklin Levy of St. Louis wrote, "This 'ethnic cleansing' of Muslims and Croatians is inhuman. International action is desperately needed now." Keith Berdak, a St. Charles resident, exhorted the Bush administration to action against the Serbs: "The Serbian aggression against Bosnia and Herzegovina seems to be with genocidal intent, protests by Serbs notwithstanding.... To try to starve entire cities is inhumanity at its worst. I would favor precision air strikes against all tanks and artillery in the stricken areas, most of which are in Serbian hands."

By August 14, 1992, the headline on the *Post-Dispatch*'s front page read, "U.N. Approves Force to Get Aid to Bosnia: Security Council Also Demands Free Access to Detention Camps." It framed the conflict from the US standpoint with a humanitarian—rather than a military—response. The same day's edition had a special report called "A Nation Torn Apart" that included a full-page graphic of the breakup of Yugoslavia and a historical chronology that described the region as the "powder keg of Europe."

With growing media coverage and increasing public awareness, the small Bosnian community in St. Louis and their local Croatian allies were focused not only on helping new refugees but also on moving US policy toward a stronger stance regarding Serbian aggression in the Bosnian and Croatian wars. They advocated for direct military intervention and lifting the United Nations–imposed arms embargo against the countries of the former Yugoslavia.

More personally, Ibro Dedić and other Bosnians in St. Louis felt desperation and helplessness about the fate of their loved ones back home. On August 12, 1992, the *Post-Dispatch* reported on a rally at St. Joseph Croatian Catholic Church. Dedić was quoted saying, "My youngest brother, the father of three little girls, has been taken away, and we don't know if he is alive or dead."

The article noted, "At the rally, participants carried signs that said 'Please, President Bush, Help Our Brothers and Sisters,' 'Bush—Stop the Killing in Sarajevo,' and 'Stop the Massacre in Bosnia.'"

An Impetus to Activism
In late 1993 theologian and peace activist Jim Douglass came to St. Louis to speak about the war in Bosnia and Herzegovina, as well as interfaith efforts to end the bloodshed nonviolently. He had traveled to the region and enlisted senior leaders of the Muslim, Catholic, Orthodox, and Jewish communities to issue a joint call for peace in Bosnia.

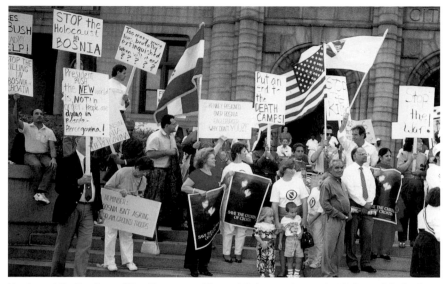

Members of the Bosnian and Croatian communities and their supporters protest in front of St. Louis City Hall, 1992. Photo courtesy of Safija Dedić Poturković.

Douglass's visit inspired local peace activists to organize the St. Louis Interfaith Project for Peace in Bosnia. Led by Bill Ramsey of the American Friends Service Committee; Teka Childress of the St. Louis Catholic Worker; and Mira Tanna from Washington University; together with Safeta Ovčina, Enes Kanlić, and Muharem Bašić from the Bosnian community; and Marlene Miller and Rich Vaughn from Eliot Unitarian Chapel in Kirkwood, the group arranged a series of demonstrations and workshops protesting the Bosnian war.

In the spring of 1994 the interfaith group sponsored a public procession for peace in Bosnia that moved from the St. Louis Islamic Center to the Jewish Central Reform Congregation to the Cathedral Basilica to a Greek Orthodox church. Prayers for peace were offered at each location by their respective faith leaders—with the exception of the Greek Orthodox church, which was traditionally allied with the Serbs. The priest there declined the invitation, but when he was told the group would peaceably assemble outside his church, he responded, "It is a public sidewalk. I can't stop you." The interfaith group helped attract more St. Louisans' attention to the Bosnian war and was instrumental in arranging assistance for newly arriving refugees.

The Bosnian and American members of the group were split on whether to respond to the war with nonviolence or military action. The Bosnians wanted the United Nations to lift the arms embargo that prevented the Bosnian government from defending itself, while the peace activists called for nonviolent action against all killing in Bosnia and Herzegovina and throughout the former Yugoslavia.

Personal Responses
Prompted in part by the absence of an effective government reaction to the atrocities in Bosnia, private citizens in St. Louis responded to the crisis in their own ways.

Julie Cummins
In a February 28, 1994, *Post-Dispatch* op-ed, Julie Cummins of Olivette asked, "Where Are Today's Schindlers?":

> It's interesting to observe people's expressions during the movie *Schindler's List*, a film about one man who rescued 1,100 Jews from extermination. It's a movie that awakens people to the horrors of ethnic cleansing and blind hatred and also to the beauty of selfless love and compassion. What intrigues me is what, if anything, happens after the moviegoers leave the theater.... Do they discuss today's holocaust, the ethnic cleansing of Muslims from Bosnia and Herzegovina?
>
> If people are so moved by *Schindler's List*, they certainly have the opportunity to do something about the genocide in Bosnia. During World War II, Americans did not have access to nearly as much in-depth reporting and visual detail of the atrocities committed against defenseless Jews. Today, however, we can watch atrocities committed in Sarajevo and other small towns while we watch television in the comfort of our living rooms.

Cummins supported lifting the UN arms embargo and assisting Bosnian refugees arriving in St. Louis. In 1995 she sponsored a Bosnian family of four to come to St. Louis after seeing their plight in Sarajevo on CNN and their plea to get out of the besieged capital.

Elsie Roth and Kathy Bauschard
In August 1994, St. Louis nurses Elsie Roth and Kathy Bauschard traveled to Sarajevo under the auspices of the Jewish women's organization Hadassah to assess medical needs. They returned to deliver millions of dollars of medicine and hospital supplies. "The sniper fire, the anti-aircraft guns in the hills above the city, the lack of water, the interruptions in electricity. Conditions were much worse than we had expected," Roth told the *Post-Dispatch*.

Roth returned the next year to facilitate the evacuation of four children and two adults to Israel for needed medical care. "It is important for us to be there to show they are not abandoned," Roth said.

Rich Vaughn
Rich Vaughn, a soft-spoken insurance broker from Kirkwood with no prior connection to the former Yugoslavia, felt called to assist the Bosnian refugees who began arriving in St. Louis. A person of deep moral commitment, Vaughn

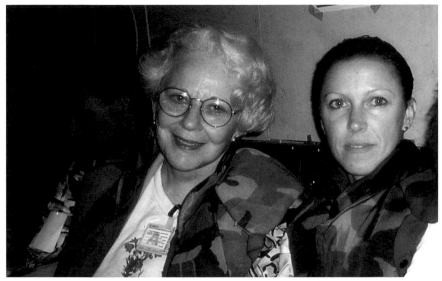

St. Louis nurses Elsie Roth and Kathy Bauschard on a UN flight to Sarajevo, 1994. Photo from the Elsie Roth Collection, Center for Bosnian Studies at Fontbonne University.

Rich Vaughn with the International Institute's Sarah Leung, 1994.

Ron Klutho with Emin Koso in St. Louis, 1999.

would end up spending much of the next several years befriending and helping Bosnians.

Over time, Vaughn became a one-person social-service agency, delivering donated furniture to dozens of new Bosnian arrivals. He was soon doing the work on a full-time basis, seven days a week, night and day. "I had no political knowledge or interest. I just wanted to help people as individuals regardless of their background," he said. Safeta Ovčina and her daughter, Aida, briefly lived with Vaughn, who opened his door to them when they had no other place to go. "[Safeta] told me, 'Rich, these families lost everything and have nothing. Can you help them?'

"I put the donated items in my garage. Everything went to these family members, although I knew that was a somewhat generic label that included friends

and neighbors from back in Bosnia," he said. In the apartments of new refugee families, it was common to see Vaughn's name and phone number written near the phone as word of his willingness to assist spread throughout the community.

"Who do you think you are, Mother Teresa?" Vaughn's partner asked at the time, exasperated by his level of devotion and the amount of energy he gave to Bosnians. "No," Vaughn responded, "but I think this is the right thing to do at this time. I am sorry that this is taking so much time, but it is what I need to be doing."

The International Institute never officially acknowledged Vaughn's actions, but unofficially its caseworkers made referrals to him to help with the needs that were overwhelming their capacity. He was flattered, figuring it was a sign of his effectiveness, free from any bureaucratic red tape. "I am not an institutionalist," Vaughn noted. "I don't deal well with hierarchies."

Somewhat reluctantly, Vaughn also became a car salesman to the community. "I grew up around cars and liked working on them. One day, Suljo Grbić came to my place to pick up furniture for a Bosnian family and noticed I had a driveway full of cars. Suljo said, 'You don't need all these cars. These men really need cars.'

"I didn't want to sell them, but they wore me down, and I agreed to sell them. I knew they couldn't get bank loans because they didn't meet the usual credit standards," Vaughn said. "My material needs were not great. My wife was deceased, and my sons were grown. I relished the opportunity to do this work on my own schedule and on my own terms. I ended up doing this work seven days a week and was on call 24 hours a day. I couldn't afford to keep my phone unattended for more than a day because my answering machine would fill up with requests."

Eventually, Vaughn moved his operation to a warehouse space donated by a local businessman. There, he continued to store and distribute donated furniture, now on a larger scale. Later asked why he pursued this work with such commitment and dedication, Vaughn said simply, "I did what I was prompted to do by both my parents, who were humble, hardworking people, who never passed up an opportunity to help someone in need. My parents taught me to never say no to someone in need."

Ron Klutho, aka "Amir Amerikanac," Amir the American

Around the same time Ron Klutho, who was similarly skilled at building relationships and also preferred to work solo, became another invaluable one-person support system for Bosnians coming to St. Louis. He was given the nickname "Amir," a typical Bosnian name, by one of the first Bosnian families he befriended. Soon, Klutho became "Amir Amerikanac"—Amir the American.

Adept with languages, Klutho built upon his knowledge of Russian and quickly learned to speak Bosnian. He was both an interpreter of language and an interpreter of American culture and society for new Bosnians. "I felt learning

"When I see a Bosnian, I see myself."

—RON KLUTHO

the language really helped me draw closer to the Bosnians I met. I felt accepted by the community," he said.

Asked about his natural rapport with Bosnians, Klutho noted that he wasn't a social worker. Rather, "I saw myself as a welcoming presence and wanted to respond to genocide and evil. Frankly, I was flying by the seat of my pants and responding to needs." Klutho became legendary for his memory of the hundreds of names, addresses, and phone numbers of the Bosnians he met, carefully entered into tiny spiral notebooks he carried in his front shirt pocket and securely registered in his impeccable memory.

Klutho gained the trust of Bosnian families who felt comfortable calling on him for help with a wide spectrum of needs. A Bosnian Roma family named their son after him. "Bosnians are resilient, resourceful, and strong people. I tried to help, but I always allowed them to make their own decisions," Klutho said. His approach allowed him to avoid the paternalisms that often creep into this kind of service work. "Before they came here, Bosnians knew America from the movies where everyone is rich, has pools in their backyards, and the streets are paved with gold," Klutho observed. "But then it was flipped on its head when people got here and saw the reality. As a result, their impressions went to the other extreme: America as a place where there are gunshots every night, and, 'I can't pay my rent, and Americans think I am stupid because I can't speak English.' I tried to show that normal life is somewhere in the middle of the two extremes."

He'd bring refugees to Castlewood State Park. They loved it: Many of them were from the countryside and were now living in city apartments. "Seeing what happened during the genocide that the world could have stopped, I felt a moral responsibility to help. I realized I couldn't change policy, but I could help in St. Louis. I wanted to do what I could to heal the wounds of those touched by genocide."

He continued, "I couldn't undo what had happened, and people had lost so much, but I wanted to encourage people for the future. And that has happened. People sacrificed so much for their children, and now their children are doing so well. I realized early on they are strong people that have survived a lot more than this. They can get through this.

"When I see a Bosnian, I see myself," Klutho concluded.

CHAPTER 5

SARAJEVO'S
LAST CHILD

The siege of Sarajevo that began in April 1992 lasted 1,425 days—the longest siege in modern history. Aid workers at the time called Sarajevo the world's largest concentration camp. Frequently broadcast live by international media, the city's slow decimation by sniper and mortar fire from the surrounding hills consumed 11,541 lives during those three and a half years, including 1,601 children. Ninety percent of those killed in Sarajevo by Serb forces were civilians from all ethnic communities. Sarajevo showed the world that the Bosnian conflict was less a war of competing armies than a slaughterhouse of victims and their executioners.

The last child to die in Sarajevo's siege was 12-year-old Nirvana Zeljković, "Nina" to her family and friends. August 27, 1995, was an uncharacteristically calm day in wartime Sarajevo. "I told her not to go out," recalled Nirvana's mother, Azemina. "It was most dangerous when it was so quiet." A mortar attack fell on the street in Sarajevo's Gorica neighborhood, where Nirvana had been playing. Nirvana was struck, and after five days in a coma, she died.

Two days after the attack that killed Nirvana, Bosnian Serbs shelled the Sarajevo Markale marketplace, killing 43 people and injuring another 84. On August 30, 1995, NATO forces began a six-week bombing campaign against the Bosnian Serb military, prompted by the marketplace shelling and the July attack and genocide in Srebrenica.

At the International Criminal Tribunal for the former Yugoslavia, Stanislav Galić, commander of the Sarajevo-Romanija Corps of the Bosnian Serb Army, and his successor, Dragomir Milošević, were found guilty of terror, murder,

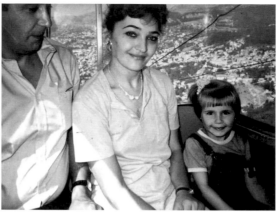

Nirvana "Nina" Zeljković with her parents, Hikmet and Azemina, before the war in a cable car above Sarajevo. Photo courtesy of the Zeljković family.

Nirvana Zeljković in a Latin dance competition. Still image from the film *Exile in Sarajevo*, courtesy of Tahir Cambis.

and inhumane acts during a campaign of sniping and shelling in the besieged Bosnian capital. In passing judgment, the tribunal noted, "there was no safe place in Sarajevo; one could be killed or injured anywhere and anytime."[34]

Bosnian Serb political leader Radovan Karadžić and his military counterpart, Ratko Mladić, were also convicted for their responsibility in the terror campaign against civilians through sniper and artillery attacks on Sarajevo. Mladić told his commanders, "Shell them until they are on the edge of madness." Both were found guilty of genocide and other crimes against humanity and sentenced to life imprisonment by The Hague Tribunal.

[34] "General Who Led Siege of Sarajevo Jailed for 33 Years by UN War Crimes Tribunal," *UN News* December 12, 2007.

An Ocean of Sorrow

After the war Nirvana's parents and her sister moved to St. Louis to take their place in the ocean of sorrow that Bosnian St. Louis had already become.

Even from her photograph, it was easy to tell that Nirvana Zeljković had been an exceptional child. She was a talented dancer, competing with her sister in events that had been held to show that the siege of Sarajevo had not broken the will of its people. The day before her death, Nina had won a Latin dance competition.

Tahir Cambis, an Australian documentary filmmaker, made a film about the Bosnian war and conditions in the capital city. By chance he had also filmed a dance competition, and he focused on Nirvana in particular. Cambis captured her spirit as she danced in what would be her final performance. His film, *Exile in Sarajevo*, featured Nirvana and her family's reaction to her death.

In the film, Nirvana's mother, Azemina, says with exhausted outrage, "Shame on the whole world for watching. For four years, they're killing our kids every day, and they say we are shelling ourselves." Cambis said, "This was portrayed as a religious or ethnic war when, in fact, it was a war between civilization and barbarism. There are times in life when you are asked to choose what you stand for. How strongly are you prepared to stand for something you believe in?"

In describing the film's purpose, Cambis added, "I thought Bosnia as a nation deserved better representation in the media than it was getting. In the power vacuum of the former Yugoslavia, people were looking for someone to blame.

"It was the Jews in the 1930s and the Muslims today," he continued. "They knew there weren't going to be sympathizers for that particular group, and they

Memorial plaque for Nirvana Zeljković. It reads: *Dear Nina, you went to school on this street / and from this street you went to eternal peace. / You will live in our thoughts.* Photo courtesy of the Zeljković family.

The Sarajevo Red Line marked the 20th anniversary of the start of the Sarajevo siege in 2012. Each chair represented a person killed during the siege, including Nirvana Zeljković. Photo by Dado Ruvić.

could wipe them out. If it had been Muslims running concentration camps for Christians, I think the war would have lasted five minutes before there'd been intervention to stop it. That's just the harsh reality of it."

Sarajevo native Alma Šahbaz, co-director of *Exile in Sarajevo*, initially viewed the film project with skepticism until she realized that its perspective on Sarajevo and its citizens was one of "great respect for what they are fighting for and what they are passing through. Even filming tragedy and putting that into the context of struggle and human courage."

When *Exile in Sarajevo* was screened at the St. Louis International Film Festival in 1998, it was named Best Documentary. Cambis used the $500 prize money to take a Greyhound bus to New York City, where the film won an International Emmy Award for Best Documentary. There, Cambis met Bianca Jagger, a prominent advocate for Bosnia, who attended the awards ceremony with him.

Return to Sarajevo

In St. Louis, Nirvana's sister Belma met and married Ernad Kovačević, a Bosnian refugee whose parents had been forced out of Banja Luka. Eventually the couple left St. Louis for Belma's hometown of Sarajevo to raise their two children. After Belma and Ernad married, Azemina and her husband, Hikmet, decided to return to Sarajevo to be closer to Nirvana's grave and memory. The pain of exile only worsened the agony of losing their daughter. As Nirvana lay

in a coma before her death, Azemina whispered in her ear, "I will never forget you. I will do something so they don't forget you."

Azemina has made good on that promise. A German journalist saw the plaque erected in Nirvana's memory, got to know Nirvana's parents, and wrote a book based on her diaries. The book is now read by German schoolchildren—a powerful way for them to see the siege of Sarajevo through Nirvana's eyes.

To commemorate the 20th anniversary of the siege of Sarajevo in 2012, organizers placed 11,541 empty red chairs down the center of the city's main street. The chairs, which stretched for half a mile, formed a visual representation of the blood that had flowed like a river in wartime Sarajevo. Small chairs placed in the front stood for the children who were killed in the siege.

The immense suffering and immeasurable dignity with which the people in Sarajevo bore their pain lives on through those who have survived and the memory of those who were lost. As Azemina says of her daughter, "As long as my heart beats, you will always be loved and never forgotten, my dear Nina."

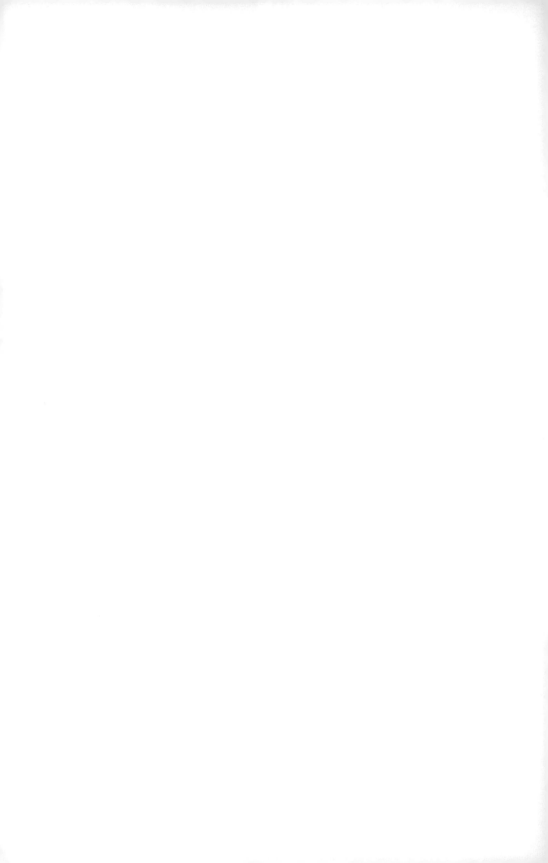

CHAPTER 6

BOSNIANS HELPING
THEIR OWN

The first group of Bosnian refugees came to St. Louis in February 1993. The second, a group of 32, came in June, and the numbers steadily increased from there. As Bosnian refugees streamed into St. Louis, Stipo Prajz's name quickly circulated as the go-to guy for help. A native Bosnian who had immigrated to St. Louis in 1951, Prajz was from Kotor Varoš in northwest Bosnia, a city many Bosnians had been expelled from.

"I would come home from work and my answering machine would be full of calls from Bosnians looking for help," Prajz remembered. To handle the flood of requests for help with interpreting, Prajz had installed three-way calling on his home phone. "I would get the Bosnian on one line and the person they wanted to speak to on another line, and then put us all together. I would interpret back and forth."

Prajz removed the regular seats from his van and installed benches so that he could transport larger groups of new Bosnian arrivals to job interviews, doctor's appointments, and English-language classes at the International Institute. "I never saved a penny during those years," Prajz said. "Any money I had went to buy clothes, shoes, and other necessities at garage sales and estate sales. I put the stuff in my basement, and when new families arrived, I would tell them to go downstairs and help themselves to whatever they needed. My wife befriended a woman who had been in the Omarska concentration camp. This lady needed a pair of shoes, but none of the ones we had fit her, so my wife took her out to buy a new pair."

During the Bosnian war, Prajz was criticized by his fellow parishioners at St. Joseph Croatian Catholic Church for helping so many Bosnian Muslims. His solid faith helped him ignore those objections. "First of all, I was helping people because I was Croatian Catholic," said Prajz. "They were people in real need who had escaped the slaughter in Bosnia." In 1993, when Croats and Muslims began fighting each other in central Bosnia and in Herzegovina, the situation became more complicated, and the criticisms Prajz received were harsher than ever.

Conflict between Bosnian and Croat Forces

Once allied against Serb aggressors, a faction of Bosnian Croats broke with those who supported a united and independent Bosnia and Herzegovina. The 1993 Vance-Owen Peace Plan had proposed a set of ethnic cantons throughout Bosnia and Herzegovina that clustered Croats, Muslims, and Serbs into separate administrative and political centers where they formed majorities, which undermined the basis for an integrated multiethnic state. Initially supported by representatives of all three national groups, the Vance-Owen Plan was scrapped when the Bosnian Serb assembly rejected it because it mandated a rollback of the 70 percent of Bosnian territory the Serbs had already captured and still controlled.

The idea to designate certain areas as "Croatian" appealed to nationalist Croat hardliners in Herzegovina and in Zagreb. With military support from Croatian president Tuđman, Bosnian Croats began to carve out their own entity of "Herzeg-Bosna," which they intended to make part of a Greater Croatia. But this plan overlooked the hypocrisy of creating an ethnically Croat mini-state in Bosnia and Herzegovina while rejecting the same idea for Serbs who held almost 30 percent of Croatia's territory for their own self-proclaimed "Serb Republic."

Some Croatians, including leading intellectual and Yale professor Ivo Banac, called for withdrawal of "support from the para-state of 'Herzeg-Bosna' as an instrument of territorial aggression upon Bosnia and Herzegovina, recognizing the government in Sarajevo as the only legitimate source of authority in the country, sincerely cooperating with all its efforts to defend the country, and promoting its cause in all international forums."

In an open letter to the *New York Review of Books*, Banac and the other authors continued, "There must be no partition of Bosnia and Herzegovina between Serbia and Croatia. Only by defending the integrity of Bosnia and Herzegovina can Croatia hope to regain its own lost territories. The cause of the expelled and displaced population of Bosnia and Herzegovina is also the cause of Croatia's own dispossessed. Only by uniting their efforts can Croatia and Bosnia and Herzegovina hope to defeat the common aggressor."[35]

[35] "The Bosnian Catastrophe, Letter from Ivo Banac, Branka Magaš, Bojan Bujić, and Vesna Domany Hardy," *New York Review of Books* 40, no. 14 (August 12, 1993).

Other Croatians doubted that Bosnia and Herzegovina would survive as an independent state. They wanted to lay claim to the parts of Bosnia that weren't under Serb control. Although thousands of Muslims had fought to defend Croatia, Croatian forces now turned on their former partners. President Tuđman sent Croatian forces into Bosnia and Herzegovina to "protect" the Croats in Herzegovina. The Muslim villages of Ahmići and Stupni Do were in their path, and the people who lived there were slaughtered. The Bosnian Croats imprisoned military-age males in concentration camps where they were tortured. In the hot summer of 1993, prisoners were kept in half-buried fuel tanks and similarly inhumane conditions.[36]

Facing the possibility of total annihilation, outgunned Bosniak forces fought back. In retaliation, Croatian forces targeted and destroyed the Ottoman-era bridge in the city of Mostar, an important symbol of unity for Bosnians of all backgrounds.

The United States, still unwilling to intervene directly in the war, wanted to isolate the Serbs and stop the Muslim-Croat fighting. Politicians in Washington brokered a deal to reunite Croatian and Bosnian forces that would put an end to military conflict between the Bosnian government and Bosnian Croat separatists who had been supported by Zagreb.

Using the threat of sanctions, the United States pressured President Tuđman to end his support for the Croatian forces attacking Bosnia and Herzegovina. Tuđman knew he needed American help to retake the areas of Croatia held by rebel Serbs. President Clinton sponsored the agreement signed by President Tuđman and Bosnian president Alija Izetbegović in Washington, DC, in March 1994.

Back in St. Louis, Prajz continued his work helping arriving refugees. "I didn't differentiate on the basis of anyone's religion," he recalled. "I helped Muslims, Croats, and even a few Serbs who were in mixed marriages. The Muslims who came from my hometown of Kotor Varoš knew members of my family better than I did. How could I turn my back on them?"

The Bosnian community still regards Prajz with deep gratitude. About his efforts, Prajz said simply, "I did what I could do." He had more than fulfilled the promise he had made to God 60 years earlier as a young seminary student to give up the priesthood for a life of service.

Stipo Prajz passed away in 2016 at age 94. During his funeral, a crowd of Bosnian mourners gathered at his gravesite. They had come to pay respect to the

[36] Jadranko Prlić, Bruno Stojić, Slobodan Praljak, Milivoj Petković, Valentin Corić, and Berislav Pušić were all charged with being part of a joint criminal enterprise to ethnically cleanse non-Croats from areas of Bosnia and Herzegovina. The indictment charged that they set up and ran a network of prison camps to arrest, detain, and imprison thousands of Bosniaks who were starved and subjected to willful killing and inhuman treatment. They were convicted for committing grave breaches of the Geneva Conventions, violations of the laws or customs of war, and crimes against humanity. http://www.un.org/icty/indictment/english/prl-ii040304e.htm.

man who had been there for them when they needed it most. They remembered Prajz as tough, opinionated, hardworking, resourceful, and, above all, dedicated to helping others. To them, he embodied the best of Bosnia and Herzegovina.

Today, the city of Kotor Varoš is part of the *Republika Srpska* entity in Bosnia and Herzegovina, predominantly inhabited by Bosnian Serbs. At the end of the war, under the terms of the Dayton Peace Agreement, extreme nationalist Serbs were given a territorial entity on 49 percent of Bosnia and Herzegovina, which was carved out of aggression and genocide. For Bosnian refugees in St. Louis who had been expelled from Kotor Varoš, it extinguished any possibility of permanently returning to their Bosnian homeland.

A Bosnian American Lends a Hand

Danijela Borić was a Bosnian Catholic whose family had come to St. Louis in the 1970s. Her family helped new Bosnian refugees when war broke out, but there was pressure to adopt a Croatian identity, which she resisted. "I was raised

Stipo Prajz with his grandsons, Andy and Chris. Photo courtesy of Mike Price.

Dijana Groth with Sarajevo singer Kemal Monteno, 1997.

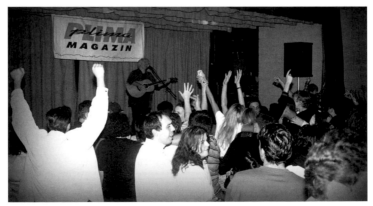

Kemal Monteno performs at the Blue Room in St. Louis, 1997.

a Catholic and taught to love everyone. 'Everyone' included fellow Bosnians, whose culture I felt like I should actually identify with because it was more like my own Croatian-Bosnian family as opposed to being just 'Croatian.'

"The type of music we listened to—which was enjoyed by all Bosnians, whether they were Bosnian Serbs, Croats, or Muslims—was distinctly different than Croatian music from Croatia. We proudly displayed the Croatian *Grb* [coat of arms] all over our home, but we had the deep feeling and shared experiences of those from Bosnia and Herzegovina."

Borić continued, "As refugees arrived in St. Louis, my mother and I would drive up and down the state streets in the city. We looked for the telltale signs that Bosnians lived there: *čipka* [lace curtains] and shoes piled up on the doorsteps. We'd knock on the door and introduce ourselves. The reaction was a rush of emotion. People shed tears of relief and gratitude.

"We brought many of the families to our home and gave them a proper meal and needed support. We didn't discriminate based on background. If anything, we helped Bosnian Muslims more. Ours is a culture of inclusion and hospitality. That's part of what it means to be a Bosnian."

Others tended to the community's cultural and emotional needs. Starting in the 1990s, Dijana Groth, a Bosnian American who came to St. Louis in the 1970s, began planning a series of concerts for the refugee community that featured Bosnian musical groups. She also published *Plima*, a monthly magazine for Bosnians both in St. Louis and across the nation.

One of the concerts, starring legendary Sarajevo singer Kemal Monteno, was held at the Blue Room near the campus of Saint Louis University in 1997. Monteno's songs were the ones Bosnians fell in love to, the ones they came to know by heart in the more innocent time before the war. Monteno stayed in Sarajevo during the three and a half agonizing years of the siege. He sang his signature song, "Sarajevo, ljubavi moja" ("Sarajevo, My Love"), with heart and soul, but it captured something even deeper that resonated with people from all over Bosnia and Herzegovina.

Monteno's St. Louis concerts inevitably became singalongs—the audiences knew and relished every word in a bittersweet atmosphere that echoed a happier past. His songs about lost love and heartbreak took on a double meaning among an audience uprooted from their homeland.

Daleko, daleko	Far, far away
srce mi je ostalo	My heart will remain
ostalo za sva vremena	Remain for all time
da kraj nje budi se	Until it wakes up next to her

CHAPTER 7

THE COMMUNITY ORGANIZES

When Dr. Enes Kanlić arrived in St. Louis with his wife, Amra, and their son, Adi, in July 1991, the war in Croatia had begun, but all was still quiet in their hometown of Sarajevo. The Kanlićs had gone to New York the previous October as visiting fellows: Enes as an orthopedic surgeon and Amra as an economist at an international business office.

"Amra went back to Sarajevo in early 1991 to extend our visit, and we both received unpaid leave for an additional nine months," Enes Kanlić recalled. "Amra also went to bring our 4-year-old son, who we had left with family in Sarajevo, and who we missed terribly. Amra worked for a short time at her firm while she was there. She was able to see and experience the deteriorating political and economic atmosphere."

Kanlić attended an orthopedic surgery conference in Los Angeles in the spring of 1991, where he met a surgeon from St. Louis who knew Kanlić's colleagues in New York. At breakfast, the surgeon asked him about his future plans. Kanlić said they were going back to Sarajevo, and the surgeon replied, "Don't you know there will be war soon there?"

Kanlić said, "I told him that was not going to happen. He gave me his card just in case and invited me to join his practice in St. Louis at Wash. U." The surgeon's prediction proved correct. The situation in the former Yugoslavia quickly deteriorated, particularly in Bosnia. When Amra and Adi returned from Sarajevo, the family decided to stay in the United States a bit longer—at least until the situation stabilized. "I called the surgeon in St. Louis, and we came there in July 1991," Kanlić said.

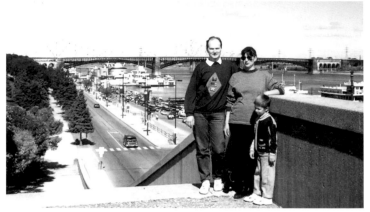

Enes and Amra Kanlić with their son, Adi, in St. Louis, 1991. Photo courtesy of the Kanlić family.

Dr. Enes Kanlić at the St. Louis Islamic Center, with Ibro Dedić to his right and Muharem Bašić to his left, 1993. Photo courtesy of the Kanlić family.

Eldin Karaiković, another orthopedic surgeon from Sarajevo, moved to St. Louis to be with Enes at Washington University's Barnes-Jewish Hospital. In October 1992, Karaiković heard about a meeting organized by St. Joseph Croatian Catholic Church, and he and Kanlić decided to go.

The community at St. Joseph had already established the American Croatian Relief Project, founded by John Klarić, Jerry Buterin, Art and Nasja Meyer, Arun and Nevenka Mitra, and others to respond to the crisis in the former Yugoslavia. They had assisted refugees from the wars in Croatia and in Bosnia and Herzegovina. "We met a group of our countrymen there who had been in St. Louis for many years, Bosnians and Croats," Kanlić remembered. "The war was already spreading throughout the former Yugoslavia, and they were organizing themselves to see how we could help."

At St. Joseph they met Muharem Bašić, who told them about an upcoming meeting at the Islamic Center. "We went to the meeting, and there were about six people there, all of them Bosniaks. There were about eight Bosnian families living in St. Louis at that time," Kanlić said.

"We were told that Bosnian Muslim refugees would start coming to St. Louis. We were asked to join their efforts to help our refugees. We had a tremendous need and urge to do something for our country and our people. It was a very, very bad time for Bosnia and Herzegovina, for people there, and for us."

The small Bosnian community in St. Louis had lost all contact with Bosnia and family members who still lived there. "We couldn't call anyone. We couldn't find out whether our parents were alive or not. Our brothers, our cousins, and friends in Sarajevo and elsewhere—for two and a half years, we had almost no contact at all," Kanlić said.

"We would spend most of the day listening to CNN for any news about what was happening in Bosnia. I left home for the hospital at 6am, working all day, and then coming home around 6pm, grabbing dinner, taking a nap, and then studying until midnight for my license certification. These were exams from medical school that I had taken 20 years ago. Now I had to take them in English in a written format I had never had in my life."

Amra Kanlić started volunteering at the International Institute. Later, she became the first of seven Bosnian caseworkers for the increasing number of refugees arriving from Bosnia and Herzegovina. "Our people were perceived as demanding because their expectations were high, and they were vocal about it," Amra recalls.

"Americans were asking Bosnians if they had refrigerators and televisions back in Bosnia. And our people were unhappy with the conditions they found here because they didn't meet their expectations. There was a disconnect and misunderstanding on both ends," Amra said.

As the war continued and more and more refugees arrived in St. Louis, Enes Kanlić and others saw the need to organize community leadership and create

a space where Bosnians could gather. "There was an obvious need to help newcomers to St. Louis and to try to help overseas with the war in Bosnia, but in order to be effective, people with some leadership experience were needed to pull the group together," he said.

Kanlić went on, "We also needed a place to get together. The Islamic Center was nice, but for many of us, we were not truly religious. We were Muslims more in name and to defend ourselves. If you are attacking us and killing us because we are Muslim, then we needed to unite to protect ourselves in order to survive."

Besides putting in grueling hours with his orthopedic surgery practice at Washington University, he and Amra were also raising two young boys: Adi, and now Alen, who was born in St. Louis. Alen was delivered by an obstetrician of Serbian descent who didn't charge the Kanlićs or bill their insurance—a reminder of the friendly and supportive intercommunal relationships in the Yugoslavia of the past.

Both Enes and Amra were anxiously following events in their hometown of Sarajevo. Looking back, Enes said, "I worried constantly about my parents. I watched every news story about the situation in Bosnia. The only news was bad news." Conditions in Sarajevo and throughout Bosnia and Herzegovina were worsening. Serb forces had encircled the Bosnian capital and cut off food supplies, electricity, gas, and water, while Serb artillery and sniper fire rained down on the city.

Amid work, family, and concerns about those who remained in Bosnia, Kanlić didn't sleep much; instead, he constructively channeled his nervous energy. He wrote and faxed letters on Washington University letterhead to city officials, asking for a building that Bosnians could use as a community center. He had heard the city sold distressed properties for $1. Kanlić figured he could get resourceful Bosnians to fix up a building. He also noticed Variety Club vans around town that had the names of local nonprofits on them. These nonprofits had donated the vans, so he wrote to them and asked for one.

They responded that the vans' recipients had to be officially organized and legally registered as a 501(c)(3) not-for-profit organization. Kanlić knew that Bašić, Dedić, Grbić, and others had set up a nonprofit called the American Bosnian and Herzegovinian Relief Association, modeled on the American Croatian Relief Project established at St. Joseph Croatian Catholic Church. The American Bosnian-Herzegovinian Relief Association printed up its own letterhead, and Kanlić got busy writing more letters and faxes. He looked at some of the properties the city had to offer, but the buildings were in terrible shape and located in areas that were too remote from where most Bosnians were living.

They found a sympathetic local businessman in Leo V. Mitchell, who owned several commercial properties throughout the city. He agreed to provide them with a space in one of his buildings for free. On a summer Sunday afternoon in 1994, Kanlić, Bašić, and Dedić toured a few of Mitchell's midtown properties.

Enes Kanlić presents a certificate of appreciation to the International Institute's Sarah Leung during the Bosnian Club's 1994 opening as Muharem Bašić looks on. Photo courtesy of the Kanlić family.

They looked at a space in the old Armory building off of Highway 40 and at a former pickle factory off of Vandeventer Avenue. Both had potential, but they needed work. The third building had a large commercial space with a warehouse on the first floor, offices on the second, and a parking lot next to the building. It seemed ideal.

"We'll take it," Kanlić declared. "Which part?" Mitchell asked. "The whole thing," Kanlić responded. They shook hands to seal the cashless deal. No contract was written or signed. When the building opened in September, they invited their benefactor to attend and be recognized by the community, but Mitchell declined. He preferred his generosity to be anonymous.

Within the 40,000-square-foot complex, the first-floor warehouse was used to display donated clothing, furniture, and household goods, such as dishes, pots, and pans. Newly arriving Bosnian refugee families were invited to take what they needed. Rich Vaughn, assisted by Emina Forić, a refugee from the Bosnian town of Kozarac who served as an interpreter and helper, came to the warehouse to drop off donations and organize the items on display. Suljo Grbić came at all hours in his pickup truck to do the same. Kanlić, still in surgical scrubs, sat in his car in the parking lot eating a sandwich, nominally supervising the whole operation.

The upper-floor offices were converted into meeting spaces. One of the rooms was set up as a library, and another was a playroom for children. The Islamic Foundation of St. Louis provided funding for new couches, tables, and chairs for the second-floor spaces. A grill was installed in the kitchen to make *ćevapčići*, a Bosnian specialty of meat sausages on bread.

A Place to Gather Is Dedicated

On September 24, 1994, hundreds packed into the building's second floor for the Bosnian Club's (*Bosanski Klub*) opening ceremony. The Croatian community was invited to the dedication ceremony, and, as Kanlić put it, "Anyone who has a good heart, who doesn't want to spill new blood, is welcome here."

Those assembled warmly welcomed Father Joseph Abramović, pastor of St. Joseph Croatian Catholic Church, who acknowledged the conflict the previous year between Bosnian Croats and Muslims, saying, "For us, the only future is one of peace and cooperation."

At the Bosnian Club's dedication ceremony, Americans who had helped Bosnian refugees were recognized, including Eric Greitens, a future Missouri governor who had assisted Bosnians in refugee camps in Croatia. Stipo Prajz and Rich Vaughn were thanked for their efforts in helping the community. Sarah Leung, the International Institute's director of refugee resettlement services, was given a certificate of appreciation.

Local poet John Samuel Tieman recited a poem he had written about the 1992 Sarajevo breadline massacre. The poem honored Vedran Smailović, the "Cellist of Sarajevo." He was a member of the Sarajevo Philharmonic who had played Tomaso Albinoni's "Adagio" at the massacre site for 22 straight days under threat of sniper fire to memorialize the massacre's 22 victims.

Vildana Bašagić, a Bosnian student from the city of Travnik who had arrived the previous month, was also welcomed. She was studying at the University of Sarajevo when the war broke out but had received a full tuition scholarship at Saint Louis University through the St. Louis Bosnian Student Project. The project was part of a national effort to bring academically qualified, English-speaking students fleeing the war to American colleges and universities. It helped relocate six students to St. Louis from Bosnia and Herzegovina: Bašagić, from Travnik; Elvir Mandžukić and Amir Kundalić, from Zenica; Lejla Sušić, from Mostar; and Edin Mandžukić and Semra Ramosevac, from Sarajevo.

A Short-Lived Success

The building was the administrative space for the American Bosnian and Herzegovinian Relief Association. Newly arriving Bosnians were enrolled as members. The club was open on weekends so people could gather and socialize. Its walls were plastered with news stories from Bosnia, wartime graphic arts from Sarajevo, and a portrait of Bosnian president Alija Izetbegović. When University of Missouri child psychiatrist Dr. Syed Arshad Husain brought teachers from the Bosnian city of Tuzla to St. Louis for mental health training, they used the Bosnian Club for their meetings and training sessions.

But after a promising beginning, the club began to falter. Teenagers who hung out there on weekends got drunk and rowdy. There were unfounded suspicions that those who organized the club were somehow profiting off of

"For us, the only future is one of peace and cooperation."

—FATHER JOSEPH ABRAMOVIĆ

it. Reflecting lingering tensions from the war, the few Bosnian Croat members drifted away. By the end of 1995, the Bosnian Club had closed. In the end, people felt uncomfortable socializing while so much innocent blood was still being shed in Bosnia.

The Kanlićs moved to Rolla, where Enes had taken a new position. The already large Bosnian community they left behind in St. Louis was about to grow exponentially.

CHAPTER 8

THE COMMUNITY
SETTLES

Kemal Kurspahić looked out over the sea of Bosnian faces—housekeepers, cooks, and maintenance workers employed by the luxury Hyatt Hotel at Union Station in downtown St. Louis. It was the fall of 1996. Hotel management had arranged for Kurspahić to speak to the Hyatt's 40 or so Bosnian employees in their own language over food and beverages.

Kurspahić was the legendary wartime editor-in-chief of Bosnia and Herzegovina's national daily newspaper *Oslobođenje*, which continued to publish throughout the three-and-a-half-year siege of Sarajevo as a leading voice of multiethnic Bosnia.

The *New York Times* reported in 1992:

> When Serbian nationalist forces began their siege of Sarajevo, Kemal Kurspahić called together the editors, reporters, and production staff of the city's main newspaper, *Oslobođenje*, and made a grim offer to those willing to work under relentless artillery, tank, and sniper fire. "I cannot promise that you will be alive when the siege is over," reporters recall Kurspahić, the 46-year-old editor-in-chief, saying. "Nor can I promise you that you will get any awards or promotions. But I can promise you this: as long as Sarajevo exists, this newspaper will publish every day."[37]

[37] John F. Burns, "Sarajevo Paper Defies War by Staying in Print," *New York Times*, October 7, 1992.

The staff faced seemingly insurmountable obstacles: the targeted destruction of the newspaper's headquarters, shortages of paper to print on, lack of electricity. There was little fuel to power the generators, which, along with the editorial staff, had been moved to a basement bomb shelter. Despite these challenges, the newspaper was published every day of the siege. *Oslobođenje* came to symbolize the ingenuity and resolute interdependence of Sarajevo's people.

Kurspahić himself embodied the professionalism and commitment he used to rally his *Oslobođenje* staff, made up of individuals from all ethnic communities in Bosnia and Herzegovina. Refined in appearance and precise in his thinking, Kurspahić spoke in thoughtful paragraphs that he seamlessly interpreted between English and Bosnian with impressive recall and delivery.

At the height of the Sarajevo siege, the *World Press Review* recognized Kurspahić as Editor of the Year for his "bravery, tenacity, and dedication to the principles of journalism." *Oslobođenje*, which translates to "liberation," was founded as an anti-Fascist newspaper during Yugoslavia's partisan resistance to the Nazi occupation of the Second World War.

Kurspahić was named a Nieman Fellow at Harvard University and moved to the United States with his wife, Vesna, and their sons, Tarik and Mirza. He became *Oslobođenje*'s US correspondent and later the managing editor of the Connection Newspaper group based in Alexandria, Virginia.

When Kurspahić met Bill Clinton in the spring of 1993, the president asked him for his advice on US policy toward Bosnia. Kurspahić responded with a succinct five-point plan: carry out airstrikes against Serb positions around Sarajevo and other Bosnian cities, lift the arms embargo, strengthen economic sanctions against Serbia, revise the Vance-Owen Plan to prevent an apartheid division of Bosnia and Herzegovina, and hold trials for war crimes.[38]

In addressing the Bosnian employees at the Hyatt, many of whom were from Srebrenica, Kurspahić was surprised that some still did not fully understand what had happened during the fall of the former UN Safe Area or that so many of their loved ones had been lost. Over time, a more complete account of the Srebrenica genocide would emerge through the proceedings of the International Criminal Tribunal for the former Yugoslavia (ICTY) and from the body of evidence uncovered by ICTY investigators, journalists, and scholars.

Although the concept of moral equivalence—the idea that "all sides" were guilty of atrocities—was invoked during and after the war, the industrial scale of the crimes in Srebrenica pointed to the state-level sponsorship of Serbia that was needed to arrange the massive, complex logistics of troops, armaments, and bulldozers to bury those who had been murdered in the genocide.

[38] Kemal Kurspahić, *As Long as Sarajevo Exists* (Stony Creek, CT: Pamphleteer's Press, 1997).

"Bosnian Hyatt Style"

Arijana Baškot, a young woman from Prijedor, was on duty at the reception desk when Kurspahić checked into the Hyatt. Kurspahić knew her family. In a possible violation of hotel rules (but in keeping with Bosnian custom), Baškot invited Kurspahić to her parents' home, where he spent an enjoyable evening eating, drinking, and talking with the Baškots until the early hours of the morning.

The hotel had cultivated a strong relationship with its Bosnian employees and printed a 32-page handbook called "Bosnian Hyatt Style" that included translations of hospitality-related words and hotel catchphrases. Vahid Sušić, a Bosnian refugee from Mostar, soon learned his own useful catchphrase. When offered overtime assignments in the hotel's laundry, Sušić replied, "With pleasure!"—a response that endeared him and his fellow Bosnians to hotel management.

"Bosnians are quickly becoming part of the American melting pot," said the Hyatt's general manager, Paul Verciglio. "Our training program gives these hardworking newcomers to the United States good jobs in which they can advance."[39]

The hotel sponsored Bosnian Day, when Bosnian employees prepared traditional dishes from their home country and shared them with their co-workers. Tim Combs, the hotel's employment manager, declared Bosnian Day a huge success. "It had a tremendous impact, not only because of the socialization, but because the Bosnians got to be in control. They had the upper hand, and the Americans experienced unfamiliarity."

The hotel's outreach to Bosnian employees also helped them solve a chronic retention problem. Turnover was usually 40 percent for hotel employees, but among the hotel's the Bosnian employees, it was only a fraction of that. Bosnians were made to feel welcomed, valued, and respected—a rare occurrence among low-level service workers who are often invisible to both management and guests. Many stayed with the hotel and were promoted or transferred to better positions. Jasmina Junuzović, hired as a concierge soon after she arrived in the United States, rose to become the hotel's human resources manager, a job she held for eight years before moving on to a similar position at another hotel chain.

The Hyatt experiment proved on a small scale what St. Louis was learning on a larger scale: that established employers could successfully integrate refugees and diversify their workplaces while developing more open-minded employees, resulting in positive benefits for their workforce, their customers, and the wider community.

Bosnians were starting to get a foothold at St. Louis employers like the Hyatt and in light manufacturing jobs, where they excelled. Bosnians' reliability and work ethic led to promotions and offers of overtime shifts, as well as a degree of economic and employment stability that was critical in rebuilding a sense of security and belonging.

[39] James Holter, "Bosnian Refugees Find Refuge at Hyatt," *Hotel and Motel Management*, September 4, 1995.

CHAPTER 9

THE COMMUNITY
MOURNS

In the United States immigrants and refugees usually advance faster economically and socially than native-born poor people. Refugees who've been resettled into poor neighborhoods are often fueled by determination to improve their situation for themselves and their children. Longer-term residents of these same neighborhoods struggle with stifled opportunities, discrimination, lack of skills, disintegrated families, and other barriers that afflict the poor.

Poor people tend to stay poor. While immigrants and other refugees are also poor, they usually do not remain so. The rapid economic and social development of war refugees and immigrants punctured another myth at the center of immigration debates in the United States. Americans often see new arrivals as a drain on economies, social services, and healthcare, when in fact the opposite is true. Immigrants and refugees fuel business development and job creation, adding to the local and national tax base while providing political, economic, and social diversity to cities struggling with declining population and infrastructure.

The improvements Bosnians made to St. Louis neighborhoods were direct and tangible. Landlords who rented apartments to Bosnian refugees were frequently astonished to find their tenants had made improvements to broken electrical and plumbing systems and had cleaned their apartments from top to bottom. As a result, many landlords began to welcome Bosnian families and other refugees, turning another assumption of American prejudice on its head: that poor people were lazy "takers" and those without an ownership stake in a property could be expected to demand but not to give back.

President Ronald Reagan had summed up this core principle of the modern market economy by saying, "Nobody ever washed a rental car." St. Louis landlords welcomed Bosnians who paid their rent on time, usually in cash, and often in person over cups of Turkish-style Bosnian coffee served in small cups with sugar cubes.

Practically overnight, old south St. Louis buildings became enclaves of Bosnian families, who did not retreat behind closed apartment doors, but instead stayed out on front porches and in back yards, barbecuing meat and roasting lamb on spits. Whole neighborhoods started to take on the look and vibrancy of Bosnian life: loud, casual, and collective. Doors were left unlocked in apartment buildings, and Bosnian neighbors would go freely across hallways to visit friends and family for coffee and conversation. But just as the community was starting to feel safe and comfortable, disaster struck.

The Murder of Selma Dučanović

Posing variously as a public-health worker and a law-enforcement officer, a sexual predator named David Martin made his way into the homes of unsuspecting Bosnians and performed bogus physical exams on Bosnian girls in the summer of 1998. Although police were alerted and the suspect was identified, tragically, it wasn't before he had kidnapped and murdered 11-year-old Selma Dučanović. Selma had been asleep in her bed when Martin abducted her, apparently entering by way of an unlocked door in the family's Bevo apartment.

The Bosnian community was deeply unsettled by Selma's murder. Martin had not only taken young Selma's life but had also stolen the little bit of security that the Bosnian community had just started to feel. For some, it was too much. Srebrenica war widow Muška Orić, who had only lived in St. Louis for six months, immediately decided to return to Bosnia with her four children. Her youngest had been another of Martin's victims.

Selma's mother, Ulfeta, had lived in a refugee camp in Croatia with Selma and her brother, Hajrudin. Her husband, Ekrem, was a soldier in the Bosnian Army. After the uncertainty of not knowing if Ekrem was dead or alive, the family reunited with him in 1995 and came to St. Louis the next year. Like many other Bosnians, the Dučanović family resettled in the Bevo Mill neighborhood to start a new life among other Bosnian refugees with what they thought was a degree of stability and safety.

Safija Poturković Dedić, one of Selma's relatives, said at the time, "The whole community at this point is grieving. Everyone looks back at the war, the mass rapes, the concentration camps, finally escaping and finding refuge—and then this happens. It's awful."[40] She described Selma as the perfect kid, saying, "She

[40] "Slain Girl's Family Had Survived the War," *St. Louis Post-Dispatch*, August 4, 1998.

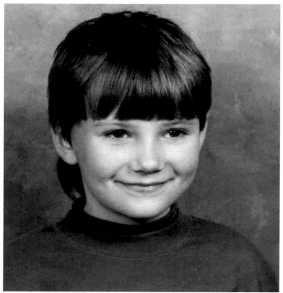

A school photo of Selma Dučanović. Photo courtesy of the Dučanović family.

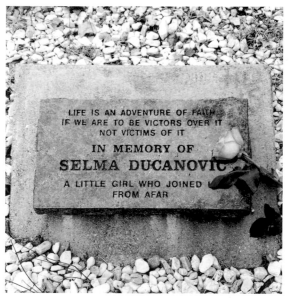

Community memorial to Selma Dučanović. Photo courtesy of the Dučanović family.

never went anywhere without asking, never did anything her parents didn't want her to do. She was getting to know her father again after being separated for so long, and they were very close. They were always together." Selma's father called her his princess.

Seemingly the entire Bosnian community attended Selma's funeral in Affton at Our Redeemer Cemetery. Bosnian Imam Muhamed Hasić presided over the graveside services. "We feel so sorry for the little girl and for her parents who gave up so much because they believed they could have a better life here," Sajma Hadzić, a Bosnian mother with two children of her own, told a *Post-Dispatch* reporter at the funeral. "This is so sad for us. Our whole community thought we could find peace. Now this."[41]

Selma's teachers from Lafayette Elementary School attended pre-burial services at the Jay B. Smith Funeral Home in Maplewood, remembering their student as "always so helpful translating into English for the other children. She was the greatest student and so liked by everyone. Selma was always smiling," said Rosemary Burr, her fourth-grade homeroom teacher.

The police concluded that Martin had found Selma by chance, after trying doors on apartments. Martin admitted to an FBI agent and a police investigator that he had found the Dučanovićs' back door unlocked. In response to this disclosure, a Dučanović family relative, Muharema Hrnčić, read a public statement to the media on their behalf. "Parents, please lock your doors and watch your children closer than ever before." Hrnčić added that the family hoped Martin would get the death penalty "so that he could not hurt any more little girls."

The St. Louis Police Department was criticized for not finding Martin before Selma was murdered. "Nobody feels worse about this than I do," a police commander said. "I assigned two detectives on this case full time when we learned of the incidents, and they looked for him. A lieutenant went to Martin's mother's home on five or six occasions looking for him on his own time."

The International Institute and the St. Louis Police Department organized well-attended community forums to reassure a panicked population, but the damage was done. Bosnian families accelerated their move from the city to the suburbs of south St. Louis County in search of greater safety, better schools, and nicer homes.

Within weeks of Selma's murder, federal prosecutors decided to seek the death penalty against Martin. After a brief trial, he was given life in prison without the possibility of parole as part of a plea agreement. At Martin's sentencing, Selma's mother addressed him through an interpreter: "I hope you will pay for what you have done, if not here, in the other world."

[41] "Bosnians Remember 11-Year-Old 'Princess,'" *St. Louis Post-Dispatch*, August 5, 1998.

Today the 4200 block of Ellenwood Avenue, where the Dučanović family had lived at the time of Selma's murder, looks desolate. There are few signs of life. Dilapidated apartment buildings and empty front porches are everywhere. Selma's brother became a St. Louis police officer. A permanent memorial to Selma rests in Bevo so that she is never forgotten.

CHAPTER 10

THE COMMUNITY FLEXES ITS POLITICAL MUSCLE

Ibrahim Vajzović looked impatiently at his watch. Standing outside St. Louis City Hall in 2004, he was waiting for other members of a small delegation of fellow Bosnians who had arranged a meeting with St. Louis mayor Francis Slay. A natural power broker, Vajzović leveraged his instincts, ability, and relationships to make things happen. He spoke no English when he arrived as a refugee in St. Louis in 1994, but 11 days later he'd gotten an entry-level job at a printing company. Because he'd work 12- to 14-hour days and take every overtime shift, his wife, Fazira, would pack him three meals before he left for work. Within six months Vajzović was the supervisor.

With Fazira, Vajzović eventually started four companies in St. Louis: a real estate business, an insurance firm, a travel agency, and a trucking company. By 2013 the companies had annual revenues in excess of $10 million and employed 50 people. One of the Vajzovićs' real estate acquisitions was the first apartment building they lived in when they moved to St. Louis.

Recognizing the need for better organization, Vajzović and others developed the United Bosnian Association to help the Bosnian community speak with one voice. Although rivalries and power struggles took place behind the scenes, Vajzović emerged as its leader.

Francis Slay was the longest-serving mayor in St. Louis history, elected to four consecutive terms. He had a good relationship with the Bosnian community, appreciating the positive role they'd played in stabilizing deteriorating neighborhoods and reversing the city's decades-long population decline. "We were

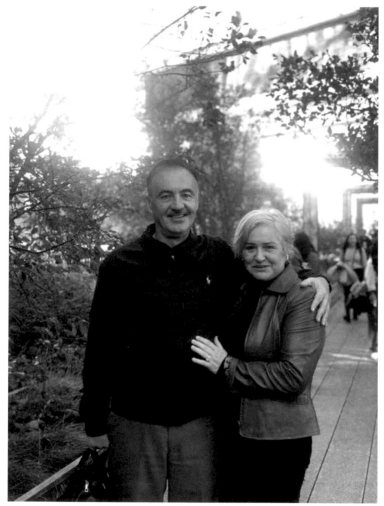

Ibrahim and Fazira Vajzović. Photo courtesy of the Vajzović family.

losing population and people more than almost any city in America before the Bosnians came," Slay said. "They've helped us revitalize this city."[42]

St. Louis recorded a population of 348,000 in the 2000 US Census. Fifty years earlier—before a mass exodus to the suburbs and the decline of its urban core—it had been the eighth-largest city in the United States with a population of 856,000. But in 2000, St. Louis dropped to 64th in population, and one in four St. Louisans lived below the poverty line.[43]

Bosnians, the newest St. Louisans, made up roughly 10 percent of the city's population. Their positive effect on city neighborhoods had already been widely acknowledged by St. Louis's political leadership. If they could be mobilized into an effective voting bloc, Bosnians could swing an election—something the St. Louis political establishment had already recognized.

When Mayor Slay emerged from his office, he stood in the doorway and greeted each Bosnian visitor with a handshake and proclaimed, *"Dobro došli!"*—"Welcome!" in the Bosnian language. More formalities followed. Officially, the meeting was to request a sister-city relationship between St. Louis and the Bosnian city of Brčko, Vajzović's hometown. "We already have several of those in place," the mayor replied. "What did they really do?" Undeterred, Vajzović described the mutual benefits of such a relationship, including in the economic sphere. Then there was the symbolic value of connecting St. Louis with an important town in Bosnia.

Indeed, the contested city of Brčko had been vital in the Bosnian war. It was key to the strategic control of the Posavina corridor that linked Croatia and Serbia through Bosnia—a major Serb war objective in its territorial aggression against Bosnia. Much innocent blood was shed in gaining control of Brčko. At the end of the Bosnian war, Brčko's status in the negotiations for the Dayton Peace Agreement threatened to end the talks before an 11th-hour concession that placed the city under international control until its final status could be determined by arbitration.

In 1987, Vajzović became president of one of the largest transportation companies in the former Yugoslavia, which was based in Brčko and employed 550 people. He was 28 years old. When the war started in April 1992, he instructed his employees to drive company trucks home to keep them out of the hands of the Serbian forces that were now attacking Bosnia. He told Fazira she had an hour to get ready to go with their two daughters, Jasmina, who was 2 years old, and Aida, who was just 12 days old.

[42] "Mayors in St. Louis, Similar Cities, Clash with Trump over Immigrants," *Bloomberg*, March 20, 2017, https://www.missouribusinessalert.com/government/81993/2017/03/20/mayors-in-st-louis-similar-cities-clash-with-trump-over-immigrants.

[43] Michael B. Sauter, "These 5 Cities Have Lost Half or More of Their Populations Since 1950," *USA Today*, updated June 11, 2019, https://www.usatoday.com/story/money/2019/06/11/5-cities-have-lost-half-or-more-of-their-populations-since-1950/39557461.

Fazira called their departure the most difficult day of her life. She escaped Brčko across a narrow bridge, holding Jasmina as her mother carried Aida. They settled temporarily in the Croatian town of Gunja, just across the Sava River from Brčko. From Gunja, they could see clothes hanging on the clothesline of their now-occupied former home.

In 2008, when Vajzović led a Missouri delegation of potential investors to Brčko and other Bosnian cities, he brought local political operative Harry Kennedy, who had risen from 14th Ward committeeman—which included the largely Bosnian Bevo neighborhood—to Missouri state senator. Vajzović introduced then-senator Kennedy to officials in Brčko, and he didn't discourage any associations they might have made with the Massachusetts Kennedys' political dynasty.

Mayor Slay was from a St. Louis social and political dynasty of his own. Slay's grandfather, a Lebanese immigrant, moved to St. Louis in the early 1900s and became an alderman. Slay's father ran a restaurant but was also involved in politics as a state representative, recorder of deeds, and influential committeeman from the city's 23rd Ward for more than four decades. Mayor Slay understood that, for new arrivals to St. Louis, politics was a pathway to power.[44]

The mayor was excited to learn that one of the delegates, Vedad Alagić, whose family were refugees from Prijedor, had been a standout soccer player. The mayor told Alagić that he had been a strong soccer player at St. Mary's High School before playing in college.

Slay then asked about particular rivalries and conflicts within the St. Louis Bosnian community, revealing an impressive knowledge of intra-communal dynamics. When the discussion turned to improving schools and reducing crime in the city, Slay acknowledged that these were major concerns. "We're doing what we can," Slay said, resignedly. As the meeting drew to a close, a member of the delegation implored him not to let the opportunity to keep Bosnians in the city slip through his hands.

When the group left the mayor's office, someone asked Vajzović if he thought Slay would agree to the sister-cities idea. Vajzović said yes: "The truth is, he needs us more than we need him." Far from asking for a political handout, Bosnians were beginning to assert their political muscle. Power had just met power.

Bosnians and other South Slavs place a high value on personal connections. The Bosnian term for these ties is *veze*—contacts that are critical for employment, education, and solving life's large and small problems. Requests are made face to face, not by telephone or email.

As refugees in a new society, their old connections had been shattered and needed to be rebuilt. Quietly and effectively, Vajzović set about building a network of relationships that would advance his own interests, as well as those of the

[44] D. J. Wilson, "The Slay Family: Back Yard Politics," *St. Louis Magazine*, August 20, 2015. https://www.stlmag.com/news/the-slay-family.

St. Louis Bosnian community. "We have established a large, sustainable community. We have our children in the schools, we own businesses. If you go to a bank, our people work there. We have succeeded here in America," Vajzović told a *St. Louis Post-Dispatch* reporter in 2007.[45]

Vajzović had figured out how to navigate the American system. He was recruited for an executive-level position in hospital administration at St. John's Mercy, a large healthcare provider, where he worked for three years. Vajzović completed his doctorate of management degree in business at Webster University and taught at its campuses in St. Louis, Bangkok, and Shanghai. He also taught at Fontbonne University, where he was a longtime member of the board of regents. In 2015, Vajzović joined the board of directors at Midwest BankCentre, which had cultivated a special outreach to the Bosnian community.

His political influence even extended to the highest levels of the Bosnian government. In 2007, Vajzović worked with the World Affairs Council of St. Louis to plan a visit by Željko Komšić, then-chairman of the rotating three-person Bosnian presidency, which was made up of one Bosniak, one Croat, and one Serb. The visit included dinner at the Ritz-Carlton Hotel and the ceremonial opening of the annual Bosnian Festival in Carondelet Park. While Komšić was in St. Louis, Vajzović made sure that he met with Mayor Slay and other officials, a reminder that politics are a two-way street.

But Komšić encountered a sour note when he visited St. Joseph Croatian Catholic Church. The gathering should have been a friendly meeting with local Bosnian Catholics who had come to St. Louis as refugees, but a small, vocal faction of the parishioners were prepared to challenge Komšić's identity as a Bosnian rather than a Croat. For Komšić and other Bosnian Croats, their Croatian Catholic and Bosnian identities were complementary, not in opposition to one another.

Even though Komšić was elected to the presidency as the Croat, he saw himself as a civic-minded Bosnian, defying hardline Croat nationalists who wanted their elected representative to advance separate Croatian interests rather than a broad agenda that would further a united, multiethnic Bosnia and Herzegovina.

Komšić had served in the army of Bosnia and Herzegovina during the war and was awarded the Golden Lily, the highest honor for military service. A lawyer by training, Komšić also earned a graduate degree from Georgetown's School of Foreign Service. After making brief remarks in the church hall, Komšić was asked by a hostile member of the parish audience what language he spoke. Komšić replied, "The language my parents taught me at home," avoiding the loaded question.

"What do you call that language?" the questioner persisted. "Bosnian," Komšić replied. Those who wanted to hear Komšić call the language he spoke Croatian rather than Bosnian erupted in moans and shouts of objections. The local security detail assigned to Komšić became tense and confused by the linguistic controversy

[45] *St. Louis Post-Dispatch*, August 23, 2007.

Bosnian president Željko Komšić and St. Louis mayor Francis Slay (center left) kick a soccer ball with US congressman Russ Carnahan and Missouri senator Harry Kennedy (right) in St. Louis. Photo courtesy of the Vajzović family.

taking place in a language they didn't understand. Visibly angry, Komšić and his entourage left the church hall.

"This was disrespectful," commented a Bosnian Croat in attendance. "Our president, a war hero, comes to St. Louis, and this is how he is treated." Vajzović arranged a return visit by President Komšić in 2013 for a groundbreaking ceremony for a Sebilj monument that the Bosnian community had donated to the city, modeled after a similar landmark in Sarajevo.

In 2015, Vajzović and Komšić visited Washington, DC, together, where they met Missouri senator Claire McCaskill and the late Arizona senator John McCain. When they walked into McCaskill's office, she hugged Vajzović like an old friend. Komšić was impressed. Senator McCaskill told Vajzović and Komšić that she was having dinner that night with President Barack Obama at the White House. When she asked if there was a message they'd like her to convey to the president, the pair urged her to impart that American leadership was still needed in Bosnia to stem the tide of division that was only getting worse.

A few weeks later Vice President Joe Biden was sent to Bosnia and Herzegovina, where he met with Komšić and other Bosnian leaders. Biden, a strong advocate for a united Bosnia, was well received on his visit, except from Serb politicians, who saw him as a threat to their separatist agenda. Bosnians had found a political voice in Washington, and Vajzović had helped deliver their message.

More than two decades after arriving in St. Louis, Vajzović looked back with satisfaction. "St. Louis has been good to Bosnians, and we have been good for

Aida and Jasmina Vajzović at Aida's graduation from Harvard Law School, 2017. Photo courtesy of the Vajzović family.

St. Louis," he said. "Most immigrants assimilate. They change their names to 'Nick' from 'Nikolai.' But we have our heritage from Eastern culture. We are more adapting than assimilating."

Vajzović continued, "Keep your religion. Remember who you are. But be open. Realize that you live in America. This is our home now. This is where our children will live. Make sure you are presenting yourself in the right way. That way, you can keep your traditions and carry that on with your children."

The Vajzovićs' daughters, Jasmina and Aida, both followed their mother's path to a career in law. Aida, a graduate of Harvard Law School, and Jasmina, a law graduate from the University of Chicago, both have prestigious jobs: Jasmina is a US attorney in Chicago, and Aida is an associate at a large New York law firm.

The Vajzovićs' son, Semir, is an electrical engineer like his father. He earned his degree from Washington University in St. Louis before getting an MBA from Webster University. He now works for Ameren, a large utility provider in St. Louis.

"I want to succeed, I want my children to be successful, and I want to be a very valued member of the community," Vajzović told the local NPR affiliate in 2013. By any of these measures, Vajzović has achieved—and surpassed—his goals.

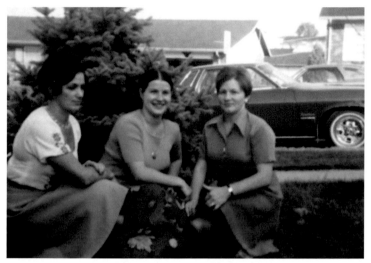

Safija Dedić Poturković (center), with friends Zilha Sarić Kireta (left) and Mejra Islamović (right), in St. Louis in the 1970s. All three helped Bosnian refugees resettle in St. Louis during the 1990s. Photo courtesy of Safija Dedić Poturković.

Suljo Grbić, one of the founding members of Bosnian St. Louis, 2014.

A "workers needed" sign at Home Depot, 2012.

Mujo Šehić in St. Louis, 2014.

Mirza Bajrić at South City Meat & Deli, 2014.

Orić, Jašarević, Bećirović, Muratović, Osmanović, and Salihović family members from Srebrenica in St. Louis, 2010.

Amela Okanović, owner of Infinity Hair Design—one of many Bosnian businesses opened in St. Louis—in 2014.

Kemal Kurspahić, the wartime editor of *Oslobodjenje* newspaper, received Fontbonne University's Civic Courage Award in 2015.

Dedication of the Sebilj public fountain in the Bevo Mill neighborhood in 2014. A gift from the Bosnian community to the city of St. Louis, the fountain is a replica of one in Sarajevo.

Srebrenica commemoration program at the Missouri History Museum, 2015.

Elvedin Pasić, the first witness at the genocide trial
of Bosnian Serb general Ratko Mladić, received
Fontbonne University's Civic Courage Award in 2021.

Commemoration walk on the 20th anniversary of the Srebrenica genocide, 2015.

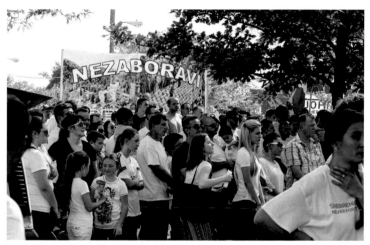

Srebrenica commemoration in St. Louis, 2015.

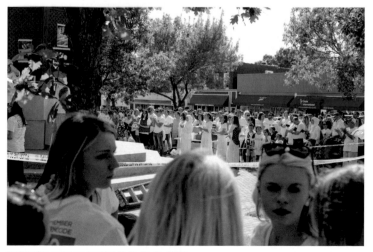

Srebrenica commemoration in St. Louis, 2015.

Srebrenica survivor Hamdija Jakubović with his daughter Ela in St. Louis, 2015.

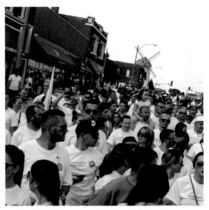

Srebrenica commemoration walk through St. Louis's Bevo Mill Neighborhood, 2015.

Attorney Nedim Ramić at Berix Restaurant in St. Louis, 2017.

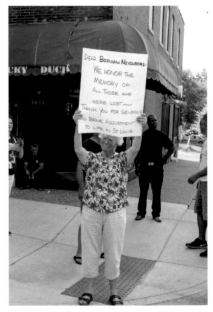

A neighborhood resident greets those taking part in the Srebrenica community commemoration walk, 2015.

Hamil and Azra Bećirović with their son Mensur in St. Louis, 1997.

Srebrenica survivors Muksa Orić and her sister-in-law Fatima Jašarević in St. Louis, 1997.

Mina Jašarević grinding coffee with traditional *mlin* grinder in St. Louis, 1996.

Hasmira Orić in St. Louis, 1997.

Cousins Naza Orić and Mina and Hanifa Jašarević in St. Louis, 1997.

Dženana Salihović and Hasmira Orić in St. Louis, 1997.

Srebrenica survivor Juso Jašarević in St. Louis, 1997.

CHAPTER 11

THE COMMUNITY
PROSPERS

Establishing a financial foothold is a daunting challenge for any new refugee. Without established credit, it is difficult to secure loans to buy cars or homes. Realizing that they could not rely on St. Louis's limited public transportation, Bosnian families needed cars to get to work or the grocery store or to visit friends in other parts of the city.

The Southern Commercial Bank branch on South Grand Boulevard hired Jasna Ajanović as a teller after her father, Halid, encouraged the bank's manager to consider employing a Bosnian who could navigate both English and Bosnian languages for their growing customer base. Although Bosnians were depositing their paychecks at Southern Commercial, they had not yet built up a credit history typically required for loans. Byron Moser, the bank's vice president, saw potential in expanding these financial services to Bosnians and moved Ajanović from a teller to the bank's loan department. "We've hired a couple of young Bosnian women as tellers. And they have told their friends; it's been strictly word-of-mouth," he told the *St. Louis Post Dispatch* in 1997.[46]

Moser acknowledged that, in the beginning, the language barrier had been an obstacle. "But having just a couple of tellers on our staff has really helped," he said. "We have taken one of the tellers, Jasna Ajanović, and we are training her for our installment loan department." Southern Commercial extended car loans to 300 Bosnian customers. "We have not had one missed payment," Moser

[46]"Finding Their St. Louis Niche," *St. Louis Post-Dispatch*, May 26, 1997.

reported, reflecting the positive reputation Bosnians had already built in the community. "They are very industrious. If I were in production, I would want these guys on my payroll.

"They understand dollars and cents real well. They are very tight with their money," Moser said. "They are very aggressive on their payments. They don't want a five-year car loan. They will buy a moderately priced used car and pay it off in two years.

"We are getting into home loans for [the Bosnians]," Moser continued. "We are getting into a niche market here, because there are a lot of lenders who do not want to be bothered with a $20,000 or $30,000 home loan."

Early Employment and Business Development
Bosnians arrived in St. Louis as a skilled labor force, with backgrounds in higher education and vocational training. Their skill sets matched St. Louis's needs. Still, the language barrier was a significant hurdle in the early employment of Bosnians in St. Louis. Even the highly educated worked in fields that did not require much knowledge of English. As a result, trained economists worked on assembly lines, doctors in factories, and engineers in the cleaning industry.

While most refugees opted for employment in the production and service industries, a few ventured into businesses of their own. When Mirzet Zulić's father, Sead, opened Bosna Gold restaurant in 1997 in the Bevo Mill neighborhood, almost no other Bosnian-owned businesses existed.[47] Over the next decade Bosna Gold's business grew and moved across the street into a larger space in an old Pizza Hut. The Zulić family expanded their restaurant and remodeled it to look like restaurants in Bosnia, complete with wood and stone interiors. Bosna Gold became a staple of St. Louis's Bosnian community, and it introduced the larger St. Louis community to Bosnian food.

Mirzet Zulić started two additional businesses within the same decade. As dozens more Bosnian-owned businesses sprung up, the area around him began to flourish. The pace of Bosnian business development accelerated even more in the late 1990s and early 2000s as a new influx of Bosnian refugees came to St. Louis, including those who had moved to the United States via secondary resettlement from Western European countries—Germany in particular.

The German government began repatriating Bosnian refugees after the war ended in 1995, ignoring the fact that most could not return to their towns and homes in Bosnia, which were now occupied by the aggressors who had driven them out in the first place. Many chose instead to come to the United States, where they had relatives from Bosnia, including several thousand who came to St. Louis.

[47] Safija Dedić Poturković, who came to St. Louis from Bosnia before the war, owned a tailor shop. Many Bosnians fleeing the war found their first jobs in St. Louis as tailors and seamstresses.

Bosna Gold restaurant sign, 2014.

South City Meat and Deli, 2014.

Bosnian Chamber of Commerce, 2014.

These later arrivals were generally better off than the earlier waves of Bosnian refugees. Having spent the past few years living and working in Germany, these Bosnians had accumulated financial resources that allowed them to bypass city housing in favor of St. Louis's southern suburbs or to purchase lower-cost distressed housing in St. Louis city that they renovated and updated for their families.

Myths about the Bosnian community receiving government money for cars and homes were growing more widespread. Bosnians who came from Germany *were* better off than their neighbors—but not because of government help. They had received benefits from the more generous European social support systems and had obtained employment, both legally and under the table in Germany. Some arrived in St. Louis already having the knowledge and resources to start businesses.

By early 2002 dozens of Bosnian-owned businesses were up and running in St. Louis, transforming an entire south-city neighborhood. Bosnian-run construction companies and service-based businesses, many of them cleaning companies, now emerged from the Bosnian community with a momentum that spurred more businesses to open. News stories about the hardworking, industrious Bosnian refugee community integrating into a new society were regularly featured in local media. Particularly after the 9/11 terror attacks, when anti-Muslim and anti-immigrant sentiment was high, Bosnian businesses and individual Bosnian success stories were highlighted, and the demand for the Bosnian workforce and businesses increased.

The Bosnian community began to consolidate its presence in south St. Louis, clustering in the Bevo Mill neighborhood from other parts of the city where they had initially been resettled. As Bosnians moved to Bevo, brick-and-mortar Bosnian businesses followed. By the early 2000s most Bosnian-owned businesses were concentrated in the area bounded by Chippewa Street, Morganford Road, and Gravois Avenue. More businesses spread along Gravois, from Taft Avenue to Delor Street, and later reached farther down the Gravois Avenue corridor.

By 2006 the area was home to more than 75 Bosnian-owned businesses, including grocery stores, insurance agencies, real estate companies, restaurants, nightclubs, cafés, and bars, as well as cleaning, construction, and transportation companies. Even the local DMV office was Bosnian owned.

A Bosnian Chamber of Commerce took shape, at first informally in 2000, then formally in 2002. It grew to about 65 members by early 2009. For many years it was led by Sadik Kukić, the owner of Taft Street Restaurant & Bar.[48]

Bosnian businesses eventually expanded beyond south St. Louis city. In 2021, Bosnian-owned businesses were distributed throughout the metropolitan area

[48] "Bosnian Community Here Takes a Big Step Forward: The St. Louis Bosnian Chamber of Commerce's Offices Will Be Cultural Center." *St. Louis Post-Dispatch*, March 28, 2009.

and region, ranging from the earlier established businesses to new export-import companies, home remodeling, and e-commerce enterprises.

Today, Missouri is home to at least 2,000 Bosnian businesses, many of them mom-and-pop operations with just one or two employees. However, multiple Bosnian businesses have employees that number in the hundreds, including Spotless Building Services, owned by Sidik Nuhanović; Vega Transport, owned by brothers Irfan and Nihad Sinanović; AA Express, owned by Fikret Poljarević; and others, each one contributing mightily to the municipal, state, and federal tax base and providing employment well beyond the Bosnian community.

CHAPTER 12

THE COMMUNITY ESTABLISHES RELIGIOUS ROOTS

Mosques—like churches, synagogues, and other houses of worship—are spiritual homes for believers. For the largely Muslim communities of Bosnians in places like St. Louis, mosques also offer important communal functions. They provide a sense of connection to the past, and they preserve language, tradition, culture, and identity.

Traditional Bosnian culture is organized around the group and a sense of interconnectedness rather than the individual. Family and community are prioritized above personal pursuits. In sociological terms, Bosnian culture—like its other South Slavic counterparts—is communitarian rather than individualistic, placing it at odds with the dominant American ethos that champions individual achievement and success.

The First Bosnian Mosque in St. Louis

Imam Muhamed Hasić has always been good with numbers. As a child in his home village of Orahovica, he excelled at math and was later a top chess player in Sarajevo, where he completed his religious training. When it came time to negotiate the price of a former bank building in south St. Louis that would become the first Bosnian mosque in St. Louis, Hasić offered the owner $301,000. "Why the extra thousand?" the owner asked. "So you can say that I offered more than $300,000," Hasić replied.

Hasić understands the psychology of money and people. He was in Bosnia visiting family when negotiations on the building price reached $320,000.

Imam Muhamed Hasić in his St. Louis office, 2014.

Minaret and mosque at the Islamic Community
Center, 2008.

He received a 3am phone call (it was 8pm in St. Louis) from a board member who informed him that the owner was demanding $340,000 and wanted an answer that day.

"Tell him $320,000, and in a day or two he'll take it," Hasić said. "And tell him some of us are on vacation," he added, before going back to bed. As Hasić predicted, a day or two later the buyer accepted $320,000, and St. Louis's Bosnian community now had a new spiritual home for a well-negotiated price.

With the closing scheduled for September 2001, the community had $280,000 in hand. The seller agreed to a personal loan of $40,000, to be paid $10,000 a month over the next four months. "But at no interest," Hasić stipulated, as participation in money lending at interest is forbidden in Islam. "We will give him a $1,000 bonus for his trouble," Hasić added, demonstrating his adeptness at reconciling divine law with human realities.

The initial closing date was delayed after two passenger jets slammed into the World Trade Center on September 11 and Al-Qaeda terrorists launched attacks on the United States. A wave of anti-Muslim animosity swept over the country. The mosque's post-9/11 opening was marred by acts of vandalism, including a serious flood when a garden hose was placed through the mail slot of the front door and the water was left running all night long.

Despite the timing and heightened Islamophobia, the Bosnian mosque has been relatively well-received and untroubled. A flurry of anxious reactions accompanied the addition of a minaret to the mosque a few years later, but they quickly died down. Since then, the thin white profile of the towering structure has become part of the south-city neighborhood's landscape, across the parking lot from a St. Vincent de Paul thrift shop, a Big Lots, and a Burlington store.

The Community Adapts and Changes

"The community has changed since I arrived in 1997. At that time I taught Sunday school, and the children were all well-behaved," Imam Hasić observed. "Now it is a different story. Too many electronics and other material things given to them with no expectations or conditions. Make a child work, even if it is something small, as a condition of receiving these things. They will appreciate it more. They will respect the parents more. And they will respect themselves and be happier."

Hasić continued, "I make the students stand when I enter and leave the classroom. This is respect for my position and authority as their *Hodža*. I tell the students to stand and greet their parents when they return home from work and they are tired. Offer them a cool drink of water or a cup of tea. Ask them how their day was, offer to be of assistance to them. This is how we show respect and how families can thrive."

Again using numbers, Hasić analyzed the human condition: "Three percent is religion, 3 percent is culture—still less than 10 percent. Ninety percent is behavior

with others. This determines who you are and the choices you make—either to honor God or to disobey His plan. We must form our young people.

"We were not ready for America, especially for big cities," Hasić said. "To be ready to keep your religion, your culture, your traditions. And then to adopt the best of this culture. There is nothing wrong with taking the good things and incorporating them. Americans are hardworking, generous people. We can look to that as a good example.

"Those from my generation thought our children would be OK here. But we cannot leave them to their own devices and the influences of this culture. They will lose their Bosnian language, culture, and traditions. We will then lose them. In 20 years a third of our people will have no connection to anything Bosnian, maybe even two-thirds. They will become Americans. Only Americans. We all will have lost something if that occurs."

In a few years the Islamic Community Center grew into the largest Bosnian mosque in St. Louis (and one of the largest in the nation), with membership expanding from hundreds into thousands of active members.

The mosque's youth group was established in 2008. It was run by Imam Šerif Delić until 2010, when the group became part of the newly formed St. Louis Islamic Center Nur. Over time, St. Louis Islamic Center Nur and another new mosque—the Bosnian Islamic Center of St. Louis, under the direction of Imam Enver Kunić—became the city's primary places of worship for Bosnian Muslims.

Dzemat Nur Opens

They came from every direction: mothers and fathers with young children, groups of young men, old men, widows with their heads covered. Parked cars spilled onto the roadside while police directed traffic. License plates reflected multiple points of departure, both near (Iowa, Illinois, Michigan) and far (New York, North Carolina, Florida). Their destination was the newest Bosnian mosque in St. Louis, at least the third such house of worship established and built by refugees from Bosnia and Herzegovina.

They were greeted by the distinctive gold-domed structure gleaming in the distance. The sheer numbers—hundreds that swelled to thousands—seemed to rattle residents in the surrounding suburban neighborhood. "What's going on?" one man living close by asked, anxiety and irritation in his voice, as people passed by on their way to the opening ceremony. In a possible concession to nervous neighbors, the mosque's traditional minaret was shortened in size, but the building's identity was unmistakable.

For a long time the purchased ground sat fallow and undeveloped. "We decided to take our time," said Alija Džekić, then-president of the Dzemat Nur Mosque. "We built only what we had funds in hand to build. We progressed slowly, but with no debt and with donated money and labor from our people."

Islamic Community Center, 2008.

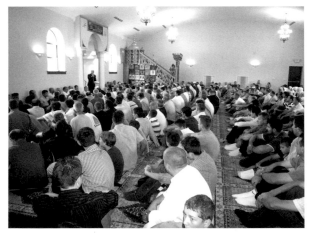
Worshippers at the Bosnian Islamic Center of St. Louis, 2009.

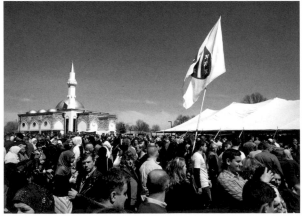
Dzemat Nur Mosque opened its doors in April 2017.

But the new mosque was finally complete and ready for its official opening. The Grand Mufti of Bosnia and Herzegovina, Husein Kavazović, had arrived along with a retinue of senior imams from every Bosnian mosque in North America.

They assembled on a dais that was hard to see because of the large crowd. Loudspeakers broadcast the Grand Mufti's message. People gathered in clusters by family and hometown, a significant number from the former UN Safe Area of Srebrenica—the transplanted remnants of that catastrophe. Now huddled in the afternoon sun with his children, Srebrenica survivor Ševko Muratović had been carried out of the Srebrenica enclave on the back of his son, Ahmet, as they escaped the fall of the city and the genocide that followed.

The Srebrenica genocide is memorialized every year on July 11 with a communal burial in Potočari, Bosnia, the site of the former UN compound where the selection process of who was to live and who was to die was carried out under the direct supervision of Bosnian Serb general Ratko Mladić. As the roundup of men commenced, Mladić boarded the buses filled with terrified deportees and gave false assurances that they would be safe. In footage of the genocide, Husein Jašarević can be seen as part of a group walking toward the waiting buses before he is directed to one side, never to be seen again.

Husein Jašarević's son, Nedim, was at the mosque's opening ceremony. Originally from a village near Vlasenica, Nedim and his family sought refuge in Srebrenica after their village was attacked by Serbs. Still as skinny as a newly arrived refugee, Nedim attributed his thin frame to excessive smoking, but other unspoken reasons hung heavy in the air. His face brightened when he talked about his daughter, Nezira, who was a student at Saint Louis University.

Also from Srebrenica, Dženana Salihović was relieved to have finished her vocal solo as a member of a traditional singing group that performed as part of the official ceremony. Like Nedim Jašarević's father, Dženana's dad, Džemail, also vanished in the genocidal whirlwind of Srebrenica's fall, his body still unrecovered to this day.

Dženana's mother, Hatiđa, was six months pregnant with Dženana when Srebrenica fell. Hatiđa delivered Dženana prematurely in Tuzla the next month. Hatiđa's brother Haso also disappeared in Srebrenica's fall. Haso's body, recovered at one of the execution sites near the former UN Safe Area, now rests in the communal graveyard in Potočari, walking distance from the home he once shared with his wife, Muška, and their four children. Muška's brother Hamdija Jakubović was at the mosque opening with his wife, Rabija—more links in the human chain of sorrow that connected many of those at the ceremony. The annual July 11 funeral in Potočari endures, as the remains of victims that have been found in mass graves over the previous year are buried.

Lost loved ones cast a long shadow over this place, even as their families assembled to mark the mosque's opening. Echoes of these memories reverberated across the deep-lined faces of those gathered in a diaspora of profound

"We were not ready for America, especially for big cities."

—IMAM MUHAMED HASIĆ

loss. They represented the human cost of the world's failure to face down aggression and the consequence of death meted out to those without recourse or the ability to alter the murderous events of more than two decades prior in the Drina River Valley.

There will come a day when even the survivors are gone, and their memories will pass with them. Someday this mosque will memorialize them and lay them to rest, but the shadows of the past will remain.

Srebrenica survivor Mirsad Salihović in St. Louis, 1998.

CHAPTER 13

REMEMBERING

SREBRENICA

"Closure" is a term used to signify the emotional acceptance and psychological integration of a profound personal loss. With the collective community loss of genocide—particularly one that is not acknowledged by the perpetrators—closure in the traditional sense is not possible. When crimes of mass violence continue to be denied, minimized, relativized, and even celebrated, to accept these crimes and "move on" dishonors the memory of the deceased. To put away these experiences is to end the unfinished work of commemoration. It erases the memory of those who've died, and then they die a second time.

In 1996, one year after the fall of the former UN Safe Area of Srebrenica, a program of remembrance was organized at the St. Louis Kaplan Feldman Holocaust Museum. Srebrenica survivor Mirsad Salihović, one of the first to arrive in St. Louis after the genocide, provided his testimony while Rabbi Robert Sternberg, Father Joseph Abramović, and Imam Nur Abdullah offered prayers and reflections from the Jewish, Christian, and Muslim traditions.

As more refugees from Srebrenica and Žepa (a second UN Safe Area attacked by nationalist Serb forces in July 1995) began to arrive in St. Louis immediately after the war, they organized themselves into an association of survivors. They focused on three central goals: obtaining definitive information about their missing loved ones, arresting and prosecuting those indicted for genocide and other crimes against humanity in Srebrenica and Žepa, and getting practical help for survivors.

The commander of Bosnian forces in Žepa, Avdo Palić, disappeared after negotiating directly with his Serb military counterparts. Thousands of others also went missing. Although not hopeful about their chances of survival, their anxious loved ones wanted them found and properly buried if they had been killed.

The survivors' group also pushed for the apprehension, arrest, and prosecution of those responsible for the killings—particularly Radovan Karadžić, the political leader of the Bosnian Serbs, and Ratko Mladić, his military counterpart. Both had been indicted by the International Criminal Tribunal for the former Yugoslavia for genocide and other crimes against humanity. Throughout the 1990s they remained at large, aided by a network of supporters and sympathizers in Bosnia and Serbia.

Finally, the survivors wanted material help for Srebrenica and Žepa refugees, especially for those still in Bosnia who had been traumatized and were living in subsistence conditions in collective refugee camps. In April 1998 the group organized a program at Saint Louis University called Waiting for Answers, Calling for Justice. It featured survivor testimonies and a keynote address by Bianca Jagger, the former spouse of the Rolling Stones's lead singer, who had become a human rights activist dedicated to working for justice on behalf of the victims of Srebrenica's genocide.

Sara Kahn, a representative from Physicians for Human Rights (PHR), addressed the group and explained how PHR was working to compile a database that could identify remains found in mass graves. The process was a forerunner to the DNA technology developed by the International Commission on Missing Persons that would later be used to identify missing loved ones and gather evidence for prosecuting war crimes.

Journalist David Rohde, who won a Pulitzer Prize for his reporting on the fall of Srebrenica, also attended the program. A second Pulitzer winner, Roy Gutman, one of the first reporters to uncover the network of Prijedor's concentration camps in 1992, sent a statement of support, as did US senator Bob Dole, a longtime advocate for lifting the wartime arms embargo imposed on Bosnia and Herzegovina and an early supporter of the process to identify Bosnia's thousands of missing and dead.

The event was a constructive outlet to channel the grief and pain of the few hundred assembled. It was a way to hold those responsible to account, to help those who survived, and to act on behalf of those who could no longer do so for themselves.

Preživjet ćemo/We Will Survive Exhibit

The Missouri History Museum in Forest Park has an imposing façade worthy of the institution's role as the repository of this region's past. Those who enter on the building's north side pass through colonnades and encounter a statue of Thomas Jefferson looking down from a pedestal. Then there's a permanent

Bianca Jagger at the Waiting for Answers, Calling for Justice program with interpreter Elvir Mandžukić, 1998.

Journalist David Rohde at the *Preživjet ćemo/ We Will Survive* exhibit opening at the Missouri History Museum, 2000.

exhibit on the 1904 World's Fair, one of St. Louis's proudest moments. Just beyond that is another gallery. In 2000 it housed the exhibition *Preživjet ćemo/We Will Survive*, the Museum's first Community Partners exhibit, which chronicled the story of St. Louis's growing Bosnian community.

At the end of the 1990s history museums across the nation began to reassess their role as guardians of the past and started asking fundamental questions about whose story gets told and by whom. Dr. Robert Archibald, then-president of the Missouri Historical Society, encouraged Museum staff to engage with different voices and groups to move the institution beyond the conventional ideas of what constitutes history. The Missouri History Museum had been newly renovated and expanded, and its staff—and the stories it told—were more diverse than ever.

Dr. Eric Sandweiss, the institution's director of research, and Myron Freedman, its director of exhibitions, were receptive to a proposal for a photo exhibit that centered on the Bosnian war and an extended family of refugees from Srebrenica who had resettled in St. Louis. That idea eventually blossomed into a full exhibition in the new Community Partners gallery space. For more than a year the Museum's staff engaged with the Bosnian community, and members of a Bosnian advisory group gave their input on what content the exhibit should include.

Ultimately, the advisory group and Museum staff settled on three sections for the exhibition: Bosnia and Herzegovina as part of Yugoslavia, the war and genocide from 1992 to 1995, and the Bosnian resettlement in St. Louis. It was a place where both St. Louisans could learn about the experiences that brought so many Bosnians to the city and where the local Bosnian refugee community could publicly have their experiences better understood and validated. An estimated 55,000 visitors saw the exhibit during its yearlong run.

The Orić family from Srebrenica was the exhibit's emotional heart. The family's surviving members all eventually settled in St. Louis as refugees, including Muška Orić, who came to St. Louis with her four children, Hasmira, Naza, Elvis, and Sajma. Muška's husband, Haso, was missing and left behind in Bosnia.

Muška last saw Haso in the chaos of the UN base in Potočari, their hometown inside the Srebrenica enclave. As the men prepared to flee into the forest from the invading Serb forces, Haso hurriedly said goodbye to Muška and their children, removing a chain from around his neck and placing it on their son Elvis. "Take care of the children," he told Muška as he left them to face the possibility of escape or, as was to occur, his death by execution.

Even though the town of Srebrenica was declared a United Nations Safe Area, the men of Srebrenica knew what would happen if the town ever fell to the Serbian forces who had besieged it for the past three years. No male of any age would be safe. As feared, 8,372 men and boys were murdered in the genocide after the town fell in July 1995.

Dutch UN forces didn't even mount a token resistance as massive Serbian forces easily overran the lightly armed UN troops. As retreating Dutch soldiers

Preživjet ćemo / We Will Survive exhibit at the Missouri History Museum, 2000.

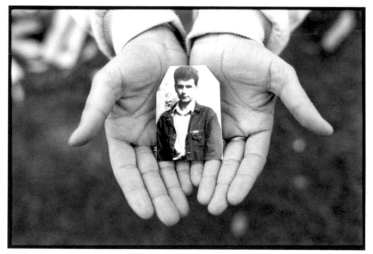

Muška Holding Haso. Photo by Tom Maday.

abandoned their posts under fire from the Serb advance, Hidajet Kardašević, a refugee from Srebrenica who later resettled in St. Louis, jumped aboard an abandoned UN vehicle and, using the mounted machine gun, began firing on the advancing Serbs in a desperate, but ultimately futile, effort to halt them.

The NATO-ordered airstrikes never came, and the Dutch command capitulated to the town's tragic fate, facilitating the turnover of thousands of men, women, and children to the Serb forces—including Haso.

A wall-size image of Muška Orić holding a photo of her husband in her cupped hands formed the exhibit's entryway. Over several months interviews were conducted in the St. Louis homes of Orić family members through Lejla Sušić, a Bosnian-language interpreter.

In the foreword to the book that accompanied the exhibit, journalist David Rohde wrote:

> The pages that follow act as both a window and a mirror. They offer us an opportunity to hear first-hand about one of the great tragedies of our times. And they offer us insight into our own lives, country, and culture.
>
> They put a human face on a distant war and explain the rich culture, fervent family loyalty, and sad history of one of the city's newest and largest immigrant groups.
>
> Imagine, if you will, that 7,500 residents of St. Louis were missing and presumed dead, and the perpetrators were allowed to live in impunity. As you read the Orićs' story, imagine that it is your family abandoning its home in chaos and fleeing for its life.
>
> Imagine that it is your brother who was interred with dozens of others in an unmarked mass grave only miles from the small town where he grew up. Read the words, absorb the images, and see that in truth this distant catastrophe was never that far away.

The family's words and Tom Maday's graphic images comprised *After the Fall: Srebrenica Survivors in St. Louis*, a companion volume to the exhibit. Through the lens of the Orić family, Srebrenica's larger story unfolded and revealed the genocide's horrific reality. The interviews began with Hanifa Orić, Haso's sister and the oldest member of the Orić family, and her husband, Behadil Mehmedović.

"We went to the UN base in Potočari. People there were mostly lost. They were just asking each other, 'What is going to happen?' People were lost, half crazy," Hanifa remembered. "When the end came, I was in my village," Behadil recalled. "We had to leave. My wife and children went to the UN base. We started at 7:30pm on July 11. I went through the woods. I was with my brothers, and during the night we were separated, and then we never saw each other again."

Haso's younger brother, Huso, and his wife, Sadika, had arrived in St. Louis with their three young boys and members of Sadika's family, including her parents, brothers, sisters, and their children. Next in line was Fatima Orić Jašarević and her husband, Juso, and their daughters, Mina and Hanifa. Fatima, Mina,

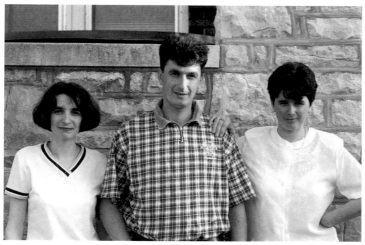

Siblings Hatiđa Salihović, Huso Orić, and Fatima Jašarević in St. Louis, 1997.

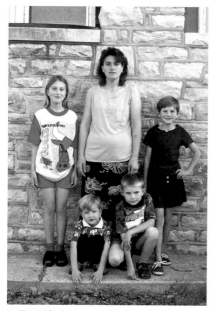

Muška Orić with her children Hasmira, Naza, Elvis, and Sajma, in St. Louis, 1997.

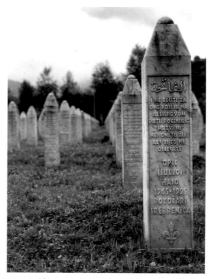

Haso Orić's grave in Potoćari, Srebrenica. Photo courtesy of the Orić family.

and Hanifa escaped the Srebrenica enclave in 1993 by boarding empty UN food convoys that had delivered desperately needed food aid to the besieged town, leaving Juso behind. "Of course, I didn't want to be separated from them, but I was relieved because we had no food for the children. We literally didn't have a single breadcrumb," Juso remembered.

Two years later both Juso's father and brother perished in the town's fall, while Juso managed to survive the trek through the woods to the Bosnian government-controlled city of Tuzla, where he was reunited with Fatima and their daughters. At first Juso's daughter Hanifa didn't recognize him.

The third oldest Orić sister, Hatiđa Salihović, was six months pregnant with her first child when Srebrenica fell. Her husband, Džemail, went into the woods with the other men, never to be seen again. He never met his daughter, Dženana, born prematurely less than a month after the fall of Srebrenica, nor has he ever been located among the still-missing dead.

The youngest Orić family member, Azra, boarded the buses in Potočari with her young son, Mensur. Azra's husband, Hamil Bečirović, took his chances with the men who went into the woods and reunited with Azra and Mensur after the trek to Tuzla, which later became known as the March of Death. Azra and Hamil came to St. Louis, where they had two more children, Haris and Dženita.

The Orić family's story was representative of the large number of survivors from Srebrenica who had come to St. Louis under similar terrifying circumstances: escaping from the former UN Safe Area; losing loved ones; and continuing refugee life in St. Louis where, despite the International Institute's best efforts, they were mostly left to fend for themselves in finding places to live and work.

The memory and experiences of the Srebrenica genocide was still raw for the Orić family, who told their stories in a direct and simple way. When the interview with Muška Orić weighed heavy with loss, she was asked about happier memories, like how she met her husband. After a pause, Muška replied, "Some memories I want to keep for myself," reflecting the distinction between disclosures that could be made public for the good of history and those that would remain private.

Content to let genocidal violence run its course during the war in Bosnia and Herzegovina, the outside world had already delved too deeply into personal realms of pain, loss, and suffering from a war that could have and should have been stopped. In 1999 staff from the International Commission on Missing Persons (ICMP) came to St. Louis to obtain blood samples from survivors that could be compared with DNA samples taken from mass graves in Bosnia to seek possible matches. The forensic evidence revealed that many of the men had been blindfolded—their hands bound behind their backs with wire—before they were executed.

Great care was taken during exhumation of the bodies to preserve intact bones for later burial and to retrieve DNA samples. The already difficult process was made even more complicated as bodies from many mass graves had been

exhumed and then reburied in secondary, tertiary, and quaternary mass graves in an attempt to cover up these genocidal crimes.

Muška Orić came to St. Louis with her four children, having lost her husband, father, and numerous male relatives in the fall of Srebrenica and the genocide that followed. She stayed just six months. Raising four small children while trying to earn enough to support them was a constant struggle that seemed to offer no hope for improvement.

For many years, Elvis Orić, Muška and Haso's son, waited expectantly for his father to walk through their door, but he never did. Haso's body was eventually found and identified. He was buried in the communal cemetery in his hometown of Potočari, today the site of the Srebrenica Memorial Center, which is dedicated to preserving the memory of Srebrenica's dead.

But for the large community of Srebrenica survivors living in St. Louis, the question of how to cope with the aftermath of unimaginable violence endures. Even the arrest and conviction of the Bosnian Serb leadership provided little solace: There's still no acknowledgment of state-sponsored aggression against Bosnia. While these larger questions elude satisfactory answers, the Bosnian community did what earlier refugee groups have done—rebuilt their lives as best they can.

Back in Bosnia, Elvis Orić now has his own wife and son. In St. Louis, his relatives mourn the loss of their previous life and loved ones. Even though they have now spent more of their lives in St. Louis than in Bosnia, they were forever shaped by their earlier experiences. They'll remember the horrors until the end of their own lives, never having the consolation of closure.

CHAPTER 14

PRIJEDOR: LIVES FROM THE BOSNIAN GENOCIDE

They came by the hundreds—old and young, Bosnian and American.

Even before the St. Louis Kaplan Feldman Holocaust Museum officially opened, the staff stopped counting those who were streaming into the building at 400. And yet, on a cold and rainy Sunday afternoon over the 2007 Thanksgiving holiday weekend, they kept coming.

A bus brought 60 Bosnian elderly into an already packed facility, where the line to get into the gallery filled the entrance hallway and backed up a flight of stairs. The overflow crowds had come to see the multimedia exhibit *Prijedor: Lives from the Bosnian Genocide*. More than two years in the making, it was a collaboration among local Bosnians from Prijedor, the staff of the St. Louis Kaplan Feldman Holocaust Museum, and students and faculty from Fontbonne University who conducted video interviews with local Prijedor survivors.

From the outset it was apparent that the day's events would be much more than an ordinary premiere. The young woman who cut the ribbon to open the exhibit, Zerina Musić, had been born 15 years earlier in the Trnopolje concentration camp just outside Prijedor. Her mother, Erzena, had been told by the Serb authorities who were present at the birth, "If the baby is a boy, we will take him. If it is a girl, you can keep her."

British journalist Ed Vulliamy, the first print reporter to gain access to Prijedor's wartime network of concentration camps, gave the keynote address following remarks by Jean Cavender, the museum's director; Amir Karadžić, the exhibit's

Opening of the exhibit *Prijedor: Lives from the Bosnian Genocide*, 2007.

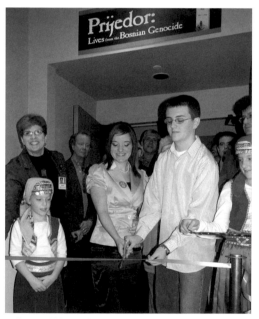

Zerina Musić (center), born 15 years prior in the Trnopolje concentration camp, cuts the ribbon with Vedad Karahodžić to open the exhibit *Prijedor: Lives from the Bosnian Genocide* at the St. Louis Kaplan Feldman Holocaust Museum on November 25, 2007.

project coordinator; and Dr. Bisera Turković, the ambassador to the United States from Bosnia and Herzegovina.

In the packed gallery space, Bosnian survivors from Prijedor and their children pressed shoulder to shoulder with Americans who came to learn more about the experiences that brought the large local Bosnian community together to live, work, and rebuild their lives in St. Louis.

Tears flowed freely among Bosnian and American visitors who quietly viewed a series of panels that detailed the events in Prijedor from 1992 to 1995. Many lingered at a display case that contained the sweater and boots recovered with the body of Dr. Kemal Cerić, one of Prijedor's intelligentsia targeted for extermination, whose remains were identified using DNA comparison with relatives. Hushed conversations stopped when visitors came to photographs of camp prisoners with visible ribcages that recalled images from the Holocaust exhibit one room over.

For some, it was the first time they had directly confronted what had taken place in Prijedor: a systematic terror campaign that resulted in the forced deportation of nearly all of the area's non-Serb population and the imprisonment of thousands in concentration camps, where they were subjected to mass killing, sexual assault, torture, and humiliation on a scale unseen in Europe since the Holocaust.

For others, the response was much more personal. For Alisa Gutić, whose father was killed in the war, the exhibit and opening program were a transformative release of the pent-up emotions she'd kept private for most of her life. "Through the years, I have cursed and hated myself for being Bosnian because I was only three years old when I lost my father," Alisa wrote in the days following the exhibit. "Still today my father has not been found, and I curse everything about the war!"

Then a student at Saint Louis University, Gutić continued: "I see my life differently now.... For years I have been searching for myself and trying to find out who I really am, and your exhibit and the beautiful messages are just leading me in the right direction. Today, I can finally say what I couldn't a week ago, that I am very proud to be Bosnian and that my hatred can one day cease as I discover who I am and why I am here today and not dead like so many in Bosnia."

"You are not supposed to be here," Ed Vulliamy said as he began his remarks, addressing the members of the audience from Prijedor. "You are supposed to be dead."

Vulliamy's words passed liked an electrical current through the tightly packed audience, who paid rapt attention to the man whom many credit with their survival. Within days of Vulliamy's August 1992 visit to Prijedor's camps, a series of reports he wrote for the *Guardian* newspaper contributed to a worldwide outcry that brought an abrupt closure to these concealed places of despair and death from which there had been no exit.

His presence before the survivors and their families conveyed an intensity to the crowded room that was palpable as they spontaneously rose to their feet to welcome him with applause. Vulliamy's impassioned call for "reckoning" with the genocide in Prijedor as a necessary prelude to reconciliation resonated deeply with Bosnians who were seeking to "forgive but never to forget" while offering important solace to those torn between looking back at the darkest chapters of their lives and moving forward into the future.

As he continued his comments (interpreted from English into Bosnian by Kemal Cerić's son, Jasmin), Vulliamy said to those assembled, "Why should you be asked to reconcile with the perpetrators of crimes that are not even admitted, let alone reckoned with?

"It is not the Jews who are building monuments in Berlin and museums like that at Dachau, but the Germans," Vulliamy remarked, as he highlighted the efforts by Serb nationalists to minimize, obscure, and dismiss the horrors documented in the exhibition.

While noting that comparisons of the Bosnian genocide with the Holocaust were not appropriate, Vulliamy related an earlier discussion with Walter Reich, then the director of the United States Holocaust Memorial Museum (USHMM). They agreed that "echoes" of the Holocaust were certainly present in the "ethnic cleansing" of Prijedor.

As the crowds moved into the museum's large atrium space for a closing reception with Bosnian food prepared according to Jewish dietary laws, Amir Karadžić—former Prijedor resident and the project's coordinator whose unannounced visit with the St. Louis museum's director two years before was the impetus for the exhibit—reflected on the massive turnout. "This was the right place and the right time. We needed to tell our story, and we are grateful to the many friends who made it possible for us to do so."

Related public programs were also developed, including a presentation by Rezak Hukanović, an Omarska concentration camp survivor and author of *The Tenth Circle of Hell*, and Jasmin Odobašić, the deputy head of Bosnia's Commission on Missing Persons.

The members of Karadžić's Union of Citizens of the Municipality of Prijedor, who developed the exhibit's content, were already discussing plans to move the exhibition to other US cities that were home to large Bosnian communities. The exhibit would eventually be displayed at more than 20 locations across the United States, including on Capitol Hill. During its run at St. Louis's Holocaust Museum, the exhibit drew more than 10,000 visitors, including Missouri US senator Christopher "Kit" Bond and Missouri congressman Russ Carnahan, who co-founded and co-chaired a Bosnian caucus in the US Congress.

"This exhibit is not meant to feed a spirit of vengeance and retribution," Karadžić said. "We want our children to know what happened in Prijedor so that they can prevent this from ever happening again to anyone, anywhere."

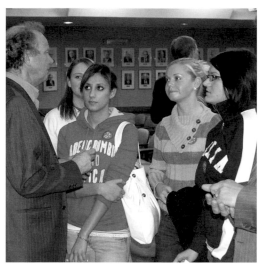

Journalist Ed Vulliamy speaks with young Bosnians after his keynote address, including Alisa Gutić, at far right.

A standing-room-only audience at the November 2007 opening program for the exhibit *Prijedor: Lives from the Bosnian Genocide*.

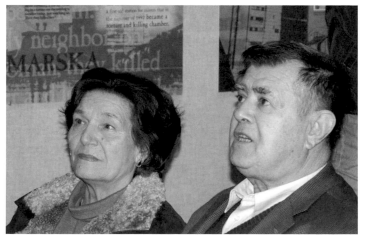

Exhibit guests Subhija and Rešad Kulenović, whose son was killed in Prijedor in 1992.

Survivor and exhibit consultant Dr. Said Karahodžić poignantly summarized the sentiments of many when he remarked, "We are ready to forgive, but first someone has to say, 'I'm sorry.'" After the exhibit was mounted, St. Louis's Holocaust Museum received a letter of protest from an organization called the Serbian Bar Association demanding that the exhibition be canceled. But in an independent review, the museum affirmed that *Prijedor: Lives from the Bosnian Genocide* met both a legal and descriptive standard for use of the word "genocide."

The Last Stage of Genocide: Denial

The root of the ongoing failures in Bosnia is that the war and current conflicts are still viewed through a lens of ethnic division. The Dayton Peace Agreement that ended the war also cemented the ethnic divide by creating a "Serb Republic" that many saw as a reward for genocide.[49]

Since 1995 authorities in the Serb Republic have prevented those who'd been expelled from their homes from returning to them. They've suppressed memorials to the victims and glorified the genocide's convicted perpetrators. In 2021 the Serb member of the presidency, Milorad Dodik, threatened to pull out of joint state institutions and then re-establish a separate Bosnian Serb Army, reigniting fears of war and creating a political crisis within Bosnia and Herzegovina.

Bosnian Serb political leader Radovan Karadžić and his military counterpart, Ratko Mladić, were charged in an indictment as the two key orchestrators of the so-called "ethnic cleansing" campaign across Bosnia and Herzegovina. Karadžić was arrested in 2008, Mladić in 2011. They were cited with genocide, crimes against humanity, and other war crimes committed in at least 40 municipalities in Bosnia and Herzegovina. Prosecutors alleged that in 18 of these municipalities, the destruction—in whole or in part—had reached the scale of genocide.

Over time the judges of the International Criminal Tribunal exerted pressure on prosecutors in the Karadžić case to reduce the charges against the accused. It was said this was to achieve a fair and expeditious trial, even at the expense of justice for the victims. Judicial pressure eventually paid off, and the subsequent indictments were reduced to just 21 municipalities, and only 8 of them were designated as places where "persecutions included or escalated to include conduct that manifested an intent to destroy in part the national, ethnical and/or religious groups of Bosnian Muslims and/or Bosnian Croats."[50]

In response to a defense motion to acquit the accused of all charges, on June 28, 2012, the panel of judges trying Karadžić dismissed one count of genocide

[49] The International Criminal Tribunal, *The Prosecutor v. Radovan Karadžić*, http://www.icty.org/case/karadzic/4.

[50] The International Criminal Tribunal, *The Prosecutor v. Radovan Karadžić*, prosecution's marked-up indictment, para. 36-47 (2009), http://www.icty.org/case/karadzic/4.

[51] ICTY Press Release: "Tribunal Dismisses Karadžić Motion for Acquittal on 10 of 11 Counts of the Indictment" (June 28, 2012), http://www.icty.org/sid/10994/en.

against him that was related to seven municipalities, including Prijedor.[51] They blamed a lack of evidence that any genocidal events had taken place in seven municipalities outside of Srebrenica, but made no reference to their own role in shaping the framework of the charges against Karadžić or the court's earlier findings on evidence of prior acts of genocide.

These judicial proceedings had alarming consequences for survivors, as well as for the contemporary political and social situation in Bosnia and Herzegovina generally, and in Prijedor in particular. Following the court rulings, Marko Pavić, then mayor of Prijedor, contended that because The Hague Tribunal had not found that genocide occurred in Prijedor, the term "genocide" could not be used or invoked in any public meeting or demonstration.

In 2012, when survivor groups in Prijedor sought to memorialize the 20th anniversary of the start of the war and genocide in their city, members of their leadership were arrested, and their front office windows were smashed. This pattern of harassment and intimidation is also reflected in the absence of any public memorial to victims of the 1992–1995 genocide. The real memorials are the empty villages and crowded graveyards of the Prijedor municipality and the stories of survivors in places like St. Louis.

The ongoing denial of genocide in Prijedor is emblematic of a wider, systematic campaign in Bosnia and Herzegovina to continue to separate the Bosnian people and solidify the policies of extermination that were carried out during the war. It's a calculated move to consolidate the political gains obtained via genocidal aggression against the social structures and long history of inclusion and mutuality that characterized Bosnian society. The denial of genocide further violates the dignity of survivors and dishonors the memory of the dead.

The Dayton Accords, which divided the country into ethnic and religiously defined entities, produced an unworkable, dysfunctional state that is now cited as further proof that creating a unified, reintegrated Bosnia and Herzegovina is impossible.

CHAPTER 15

COMING OF AGE IN
A TIME OF WAR

The genocides in Prijedor in 1992 and in Srebrenica in 1995 bookended the "ethnic cleansing" of Bosnia and Herzegovina. Tightening the focus on these cataclysmic events reveals how genocidal violence shaped the lives, experiences, and memories of countless people. Here are just a few of them.

Dijana Mujkanović

Dijana Mujkanović was very close with her father.

In 1992, as the Serb takeover of Prijedor began, Dijana and her father, Senad, went to the market to buy milk. Outside the market her father was arrested by police officers, all of whom were Serbs. Dijana exchanged glances with her dad as he was put in the police car. The arresting officers told him not to make a scene. As the car pulled away, Dijana was left alone, crying on the street. She was 6 years old.

Senad had been a policeman in Prijedor and was arrested by three fellow officers. Dijana remembered they put Senad in the same kind of police car he had driven. Weeks earlier, her dad had been fired from the police force for being a Muslim, the first step in the violent purge of Prijedor's Muslims and Catholics. After his dismissal, relatives had urged Senad to flee Prijedor with his wife and kids. But Senad assured them that everything would be OK.

At first, Dijana's mother told her that her father had gone on a business trip. But Dijana knew her mother was lying and that she would never see her father

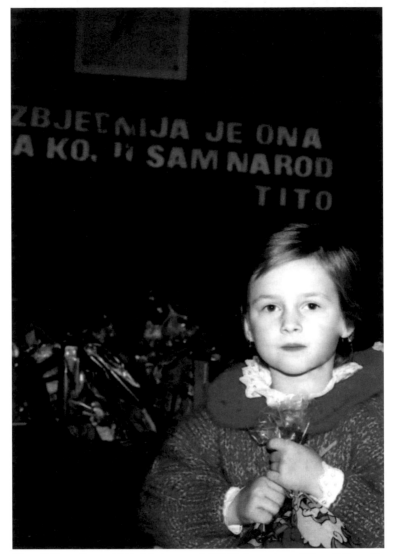

Dijana Mujkanović as a child in Prijedor, around 1991. Photo courtesy of Dijana Mujkanović.

Dijana Mujkanović at her father's grave in Prijedor. Photo courtesy of Dijana Mujkanović.

again. Dijana clearly remembers having the conversation with her mother in their living room, but her recollection of her father's arrest is fragmented and mixed with what others have told her about the event. The only thing she knew for sure was that he had been arrested by his work colleagues, was gone, and was not coming back.

For a long time after, Dijana's family didn't talk about what happened to Senad. They only said that he had disappeared.

When Dijana returned in the fall to her school that had mostly been ethnically purged of Muslims and Catholics, she was one of only two Muslim students left in the classroom. One day children whose fathers were "fallen soldiers" were invited to line up and receive parcels. Dijana dutifully took her place, only to be guided away from the line by her embarrassed teacher. "Isn't my father a fallen soldier?" Dijana asked. By "fallen soldiers," they had meant fallen *Serb* soldiers.

In 2016, on the anniversary of her father's death, Dijana wrote in detail about the experience and what it meant to her:

> I was only 6 years old when the war reached my hometown. A few months before my 1st grade graduation, my father, whom I loved dearly and immensely as only a small child can, was taken from me and brutally murdered in a local factory.
>
> For the next 14 years, I was left to wonder what had happened to him. His remains could not be found and we could not give him a proper burial. When we finally did, I realized that I did not feel much better because nothing remotely close to justice has been achieved for the victims of Prijedor.
>
> Today in Prijedor, denial runs as rampant as it did that year when communities

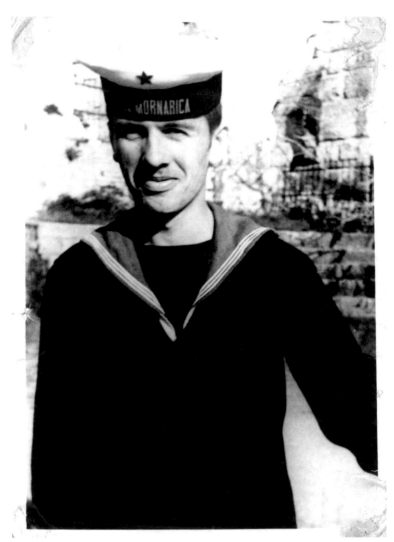

Dijana's father, Senad. Photo courtesy of Dijana Mujkanović.

turned a blind eye to the horrors befalling their compatriots. But such is war; cruel, unforgiving and full of betrayal.

24 years ago today, my family and I, along with all other non-Serbs in our small town of Prijedor, were ordered to wear white armbands and hang white sheets on our windows to be easily identified.

This request sought to alienate us from the rest of society and label us undesirable, unworthy and less than human. It was successful because what followed was a vicious campaign of ethnic cleansing and genocide that led to a near-complete extermination of the non-Serb population from Prijedor.

More than two decades later, we are yet to gain recognition for the gruesome violence and humiliation we suffered at the hands of the state, as well as our own neighbors and friends.

Even with all the ignorance of a small child, the imminence of death was all too real. But today as with years before I mark it because, although I have lost loved ones, I am still alive and survival comes with responsibility.

Most importantly, today I mark this day not just for my father, my family, my community and myself, but also for those who continue to suffer in conflict and war around the world.

Dženana Salihović

Srebrenica is never far from Dženana Salihović's thoughts.

Dženana was born a month after the July 1995 fall of the former United Nations Safe Area of Srebrenica in eastern Bosnia. In the days to come 8,372 men and boys were systematically murdered. Among the dead was Dženana's father, Džemail, then just 21 years old.

Dženana's pregnant mother, Hatiđa, joined the panicked mass of women and children at the UN base at Potočari who boarded buses while men of every age were ordered to one side and led off to execution sites. In the genocide that followed, Serb soldiers pushed aside lightly armed Dutch UN peacekeepers and then rounded up, hunted, and executed thousands of Muslim males.

In the database maintained by the International Commission on Missing Persons in the former Yugoslavia, Džemail Salihović is recorded with a date of disappearance—July 11, 1995—and the place he was last seen: In the *šuma* (woods), where men fled in an attempt to escape the "iron ring" of Serb tanks and heavy weapons that encircled the Srebrenica enclave.

Džemail's remains have never been found, a source of anguish for the daughter he never met. When Dr. Sarah Wagner, the author of two books on the Srebrenica genocide, was in St. Louis in 2011, she met privately with Dženana and her mother in their family's home to explain the forensic process of identifying the missing by using DNA matching from a relative's blood sample to verify the bones found in mass graves all around Srebrenica. Dženana's disappointment was evident when she realized that there were no new methods available to locate her father.

Dženana Salihović with her mother, Hatiđa, in St. Louis, 1998.

Dženana Salihović in 2018. Photo courtesy of Dženana Salihović.

Srebrenica commemoration walk in St. Louis, 2015.

She thanked Dr. Wagner for coming, excused herself, walked into her room, and closed the door.

Dženana has grown into an intelligent, kind, outgoing woman. As she turned 21 years old, her thoughts focused on her father, whose life ended just after his own 21st birthday.

Dženana wrote:

> As I plan for my 21st birthday, all I can think about is you. I know you would have been a dad at an early age, but your life still would have been your life. I know you probably never thought you would be gone so soon. You had dreams and hopes for your future just like any young adult.
>
> I'm sorry that you didn't get to experience all the stuff you wanted to yourself, but I know you are experiencing them through me. As I get older, I hope to become the person you pictured me to be: a loving, caring, smart girl who enjoys life just as much as you did.
>
> I know that no matter where I go or what I do, you will always be there with me. The life that I am living, I am living for the both of us. I hope that you are watching over me and you're just as happy as me.

On July 11, 2015, Dženana was one of the thousands who gathered for a march through the Bosnian neighborhood in south St. Louis to commemorate the 20th year since the fall and genocide in Srebrenica. Dženana was purposeful as she moved with the somber, silent crowd. At the end of the walk, she said simply, "I really miss my dad."

As Dženana tries to make sense of the grief and longing for the father she never knew, he lives on through the daughter he never met. The children of those who were lost embody hope in the unrealized promises and dreams of their fathers—one of the few flickers of light that shine from those very dark times.

CHAPTER 16

THE ERA OF
THE REFUGEE

Ours is the era of the refugee, with millions of people displaced from an aston-ishing array of countries. In St. Louis alone there are refugees from more than 40 countries, from Afghanistan to Vietnam. Unlike immigrants, refugees leave their home countries not out of choice but out of necessity. Most are fleeing political violence perpetuated by those who have different ethnic or religious backgrounds. Today there are nearly 71 million people who have been forcibly displaced throughout the world: 41 million of them are internally displaced, 26 million are refugees, and 3.5 million are asylum seekers.[52]

Just as societies were becoming more religiously diverse and multiethnic, organized movements all over the globe have championed the monoculture of the majority and warned against the inherent dangers posed by groups defined as the "other."

America's Immigration Ambivalence
America has a love-hate relationship with refugees and immigrants. On the one hand, Americans see ourselves as a nation of immigrants. We rightly celebrate the hard-earned accomplishments of those who came to the US with almost nothing and rebuilt their lives in a land of openness and opportunity. When the

[52] United Nations High Commissioner for Refugees, "Figures at a Glance," https://www.unhcr.org/en-us/figures-at-a-glance.html.

pendulum swings the other way, we see immigrants and refugees as threats to the status quo and unwanted competition for jobs.

Social attitudes and political considerations have long shaped US immigration policy. The first refugee legislation was the 1948 Displaced Persons Act, which paved the way for the admission of 650,000 Europeans who became refugees after World War II. Later legislation addressed those fleeing Communist regimes in Eastern Europe, including Yugoslavia, as well as Korea, China, and Cuba.

In 1956 the US attorney general was given discretion to grant entry to those who had an urgent humanitarian need. In the 1960s and 1970s this discretion was applied to Cubans and people fleeing the Indochina wars in Southeast Asia. With the passage of the Refugee Act of 1980, the US government moved from an ad hoc approach to establishing a permanent, standardized system for resettling refugees. Since 1980 more than 2 million refugees who've been forced from their homes by conflict and oppression based on religion or ethnicity have been resettled to the United States.[53]

According to the 1980 law and the United Nations 1951 Refugee Convention, refugees need to demonstrate that they have been persecuted, or have reason to fear persecution, on the basis of one of five protected grounds: race, religion, nationality, political opinion, or membership in a particular social group.[54]

The first wave of refugees both nationally and in St. Louis was from Southeast Asia (Vietnam, Laos, and Cambodia) after the Vietnam War ended in 1975. Soviet Jews followed. The wars in the former Yugoslavia were the next large driver of refugee resettlement to the United States, including St. Louis. Beyond the traditional coastal areas of resettlement in places like New York City and Los Angeles, smaller gateways for refugee placements began to open up in cities such as Utica, Rome, and Binghamton, New York; Burlington, Vermont; Des Moines and Waterloo, Iowa; Louisville, Kentucky; and Jacksonville, Florida. In these small- to medium-size metropolitan centers, Bosnians and other refugee groups have had an outsize impact on their communities, often helping to reverse population decline, jumpstart economic stagnation, and stabilize neighborhoods.[55]

Bosnian Refugee Resettlement
As many as 2 million Bosnians fled the war and resettled outside of Bosnia and Herzegovina. About 1.4 million Bosnians remain in the diaspora following the

[53] Brookings Institution, "From 'There' to 'Here': Refugee Resettlement in Metropolitan America," Living Cities Census Series, September 2006.

[54] Council on Foreign Relations, "How Does the U.S. Refugee System Work?" https://www.cfr.org/backgrounder/how-does-us-refugee-system-work.

[55] Brookings Institution, "From 'There' to 'Here,'" September 2006.

1992–1995 war. Including their US-born children, 390,000 of them live in the United States, more than any other country.[57]

During those same years, the International Institute of St. Louis directly resettled Bosnian refugees—at first in small numbers, and then in much larger ones—as Germany began repatriating Bosnians after 1995. Germany initially resettled 320,000 Bosnian war refugees. When the war ended, 246,000 were repatriated back to Bosnia. The German government claimed it had only granted them temporary protection and not full refugee status.[58]

Bosnians in Germany then faced the prospect of returning to the hometowns from which they had been "ethnically cleansed," even as those who expelled them still held positions of power. A large number—52,000 in all—chose to go to another country. Many came to St. Louis. Just 22,000 of the wartime total of 320,000 Bosnians remained in Germany as of 2005.[59] The increasing numbers after 1996 reflect this shift.

Catholic Charities resettled several thousands more. At the peak of resettlement, 30 Bosnians a week were arriving in St. Louis.

Period of Adjustment

Unlike immigrants who choose to relocate to a new country, refugees are given little choice or preparation in making decisions about where they will live. Their experience is compounded by varying degrees of trauma, uncertainty, and fear of the unknown. In short, they face an uphill battle from the beginning.

As the war continued, increasing numbers of refugees from Bosnia and Herzegovina began to come to St. Louis. Accustomed to the government bureaucracy in Socialist Yugoslavia, Bosnian refugees at first struggled to understand that privately supported refugee resettlement agencies like the International Institute of St. Louis were not a branch of the US government.

Bosnian refugees arriving in St. Louis were given limited amounts of government support in the form of cash assistance and food stamps, but they had to repay the government for the plane tickets that brought them over from Europe. The amount of government assistance was determined by family size, and most benefits would run out within the first six months.

Another major adjustment in expectations was the "sink or swim" philosophy prevalent in the United States that assumes rapid adaptation, self-sufficiency, and full assimilation can take place within a short period of time. Young, healthy, resourceful, ambitious refugees thrived in a system like this, which placed op-

[57] Marko Valenta and Sabrina P. Ramet, eds., *The Bosnian Diaspora: Integration in Transnational Communities* (Surrey: Ashgate Publishing, 2011).

[58] Davor Šopf, "Temporary Protection in Europe after 1990: 'The Right to Remain' of Genuine Convention Refugees," *Washington University Journal of Law and Policy* 6 (January 2001).

[59] Valenta and Ramet, *The Bosnian Diaspora*, 4.

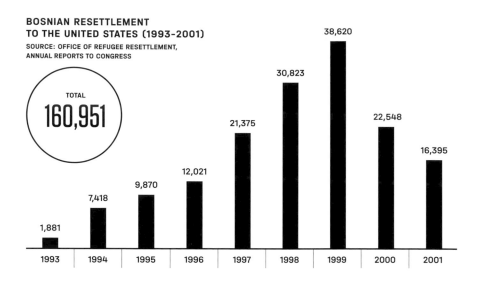

**BOSNIAN RESETTLEMENT
TO THE UNITED STATES (1993-2001)**

SOURCE: OFFICE OF REFUGEE RESETTLEMENT,
ANNUAL REPORTS TO CONGRESS

TOTAL
160,951

38,620
30,823
22,548
21,375
16,395
12,021
9,870
7,418
1,881

1993 1994 1995 1996 1997 1998 1999 2000 2001

**BOSNIAN RESETTLEMENT
TO ST. LOUIS (1993-2001)**

SOURCE: ST. LOUIS INTERNATIONAL INSTITUTE,
BOSNIAN IMMIGRATION & IMPACT, 2015

TOTAL
6,530

1,335
1,176
996
920
602
591
536
342
32

1993 1994 1995 1996 1997 1998 1999 2000 2001

portunity above support. Older, less healthy, traumatized refugees were likely to have a harder time adapting, having only limited financial support and a very basic social safety net that excluded mental health services and other necessities, such as dental care, that were tied to full-time employment.

Finding employment is the main objective of most social service support, which also offers crash courses in English and assistance with enrolling children in school. Although the early stages of this orientation seemed harsh, the longer-term goals were to attain social integration, economic independence, and connection with established civic and educational institutions. Bosnian refugees who adapted to these expectations did well because this philosophy of self-sufficiency reflected the dominant American values. At the same time, the

demands of work (Bosnians often held more than one job) and the hectic pace of life undermined the strong social bonds of the communitarian Bosnian culture.

"Work, home. Home, work. That is all I do. And a little sleep," said Nedim Jašarević, a refugee from Srebrenica, not long after arriving in St. Louis. He and his family moved from the city to the suburbs, drawn to the safer neighborhoods and better schools they offered.

In contrast, Bosnians who were resettled in European countries found a continuum of care and social services, with extended financial support and guaranteed healthcare. But they also found their status was that of permanent outsiders, never as members of the host country. Although their basic needs were met, they had little opportunity or incentive to improve their status.

For all the faults and limitations of US support for refugees, many of those who come here with a do-whatever-it-takes mindset and the willingness and ability to work hard have found long-term success, opportunity, and a sense of belonging in St. Louis. The high caliber of the Yugoslav educational system, supportive family structures, and expectations of achievement were important drivers that helped move Bosnians up the social and economic ladders.

As with everything that is a gain, there are corresponding and unintended losses. With parents spending so much time at work, children were left at home alone. When parents were at home, they were exhausted by the end of working second or third shifts, too tired to pay much attention to their kids. The cohesion of Bosnian families and their strong parental authority eroded. Children were often able to flip the power dynamic within families because they learned English more quickly and proficiently. Parents had to depend on their children as interpreters, sometimes in inappropriate settings like medical appointments, and as translators for complicated insurance forms or school notices.

Busy families also had less time to spend with one another and with their larger network of extended family and friends. It used to be common for Bosnian families to gather in backyards and parks for barbecues of roasted lamb and casual hours of social time. Eventually such gatherings were only held for special occasions, like graduations, birthdays, or weddings. The venues moved from backyards to banquet halls, reflecting Bosnians' greater financial capacity and what is deemed more "American."

CHAPTER 17

RECOLLECTING THE PAST: THE BOSNIA MEMORY PROJECT

The Bosnian war killed tens of thousands of people and displaced millions more. Along with them, the social memory of Bosnia and Herzegovina as a shared cultural space was also destroyed.

Serbian and Croatian aggressors specifically targeted the Islamic culture and heritage of Ottoman Bosnia; this also meant a concerted effort to eradicate the Bosniak community in Bosnia and Herzegovina. Mosques, the visible manifestation of Islamic life and culture, were systematically obliterated in towns and cities throughout the country.

The Aladža Mosque in the city of Foča, a UNESCO World Heritage Site built in 1549, was blown up by Serb forces in April 1992, then bulldozed and turned into a parking lot. Serbs later claimed a mosque had never been there. Between April and June 1992, every mosque in Foča—12 in all—was destroyed.

The Ferhadija Mosque in Banja Luka, a UNESCO World Heritage Site built in 1579, was blown up on May 6, 1993, the Orthodox holiday of St. George. The Ferhadija Mosque was one of 16 in the city that were destroyed between 1992 and 1995.

The war in Bosnia and Herzegovina demolished a total of 614 mosques (in addition to 733 other waqfs[60]), while 307 mosques sustained considerable damage. The number of damaged and destroyed mosques represented more than 80 percent of the country's mosques that had existed prior to the war.

If a multireligious Bosnian past were to be rewritten on a blank slate, the tangible representations of that past and the people who inhabited those spaces

[60] See next page.

had to be eliminated. These mosques had survived for centuries through two world wars and, in the case of the Ferhadija Mosque, a massive earthquake in the 1960s, but they couldn't withstand the 1992–1995 war.

The Bosnia Memory Project

From a cluttered office on the third floor of Fontbonne University's East Building, Dr. Ben Moore has thought a lot about the destruction of social memory in Bosnia and Herzegovina. Surrounded by Bosnia-related books, articles, and artifacts—including panels from the exhibition on the Prijedor genocide— Moore has been consumed with the idea of preserving the memory and experiences of Bosnian genocide survivors living in St. Louis.

The founder and director of the Bosnia Memory Project (now the Center for Bosnian Studies), Moore has taught courses on the Bosnian immigration experience at Fontbonne since 2006.[61] He first taught the course with his Fontbonne colleague, historian Dr. Jack Luzkow. Together with local activists and survivors from Prijedor, they developed the multimedia exhibit *Prijedor: Lives from the Bosnian Genocide*. Moore's students conducted interviews with local Bosnians from Prijedor, and Luzkow wrote the text that chronicled the genocide.

Unassuming and modest, Professor Moore has been a specialist in 17th-century British literature. His interest in preserving the memory of Bosnia, however, has gone well beyond the academic. Moore has immersed himself in the culture. He has studied the Bosnian language and made numerous trips to Bosnia. On his first trip to the country he was part of a research team led by Amir Karadžić. They visited the sites of the Omarska, Keraterm, and Trnopolje concentration camps.

Moore recognized the urgency to record and preserve immigrants' memories. "I had done some other research into earlier immigrant groups in St. Louis, and there was a pattern that I could see, that it took one generation for the memories of the homeland and the migration to be forgotten. And it was clear that there was a window that was opening as people became more accustomed to life in St. Louis and therefore readier to speak to others about their experiences, but that one day that window would start closing. And so we had a limited amount of time to act, and we're in the midst of that now."

[60] A *waqf* is a permanent charitable endowment under Islamic law. It typically involves donating a building, plot of land, or some other assets for Muslim religious or charitable purposes. In Bosnia and Herzegovina, numerous forms of waqfs exist, most notably mosques and educational institutions. Those waqfs were often built on donated land, with donated funds and labor. Once built, they would become property of the Islamic Society of Bosnia and Herzegovina and part of the greater waqf system that would serve a specific purpose. Some of the well-known waqfs in Bosnia still in use include one by Gazi Husrev-beg, which dates to 1585.

[61] Moore retired in 2021. Dr. Adna Karamehić-Oates, a Bosnian scholar and prominent community leader, now directs Fontbonne's Center for Bosnian Studies. Moore remains a senior researcher for the Center.

Dr. Benjamin Moore, founder of the Bosnia Memory Project (now the Center for Bosnian Studies), in the Bosnian city of Banja Luka, 2007.

The Importance of Preserving Memory

In a 2020 interview with the *St. Louis Business Journal*, Moore explained that preserving memories of the war and genocide in Bosnia and Herzegovina is critically important for several reasons. "One is that the perpetrators of the genocide really wanted the people we're interviewing to disappear. And if the memory gets lost, it's serving the interest of the people who were perpetrating the ethnic cleansing," he said. "Recording refugees' stories helps thwart the perpetrators' attempts to erase memory and rewrite history."

He continued, "In addition, history tends to be reductive. Official histories tend to simplify the narratives and all too often resort to easy explanations. And with these interviews, instead what we see is really very complex lives that fly in the face of many of the easy explanations that have been offered outside of Bosnia for what happened in Bosnia."

Among these easy explanations, Moore said, is the idea that the country's ongoing struggles are rooted in centuries-old blood feuds and ethnic hatreds. Moore's interviews with Bosnians have instead revealed that they lived in well-integrated communities with friends of many different backgrounds until politicians began to sow ethnic division to advance their own agendas.

Moore was also concerned about the impact that genocide denial has on survivors. "Genocide denial does further violence to the memories and to the people who hold those memories, and it does violence, of course, to the truth. Those who deny the genocide go to great lengths to justify the unjustifiable," he said.

Many Bosnians have found that speaking with Moore has enabled them to do something tangible with their memories that have nowhere else to go; it's

allowed them to develop a coherent representation of a trauma that they might not deal with on a day-to-day basis. "When people have the ability to talk about it from the beginning to the end, it is a way of providing some framework for those memories that otherwise are just bouncing around," Moore said. "I don't think there is anybody who is ready or interested in talking about this all the time. These memories of the war and genocide are always there, but they have taken their place alongside other facets of life." Understandably, not everyone is eager to talk.

Even as the Bosnian Memory Project has sought to ensure that these refugees' stories aren't lost to history—or some rewritten, reductive version of it—Moore acknowledged how difficult it is for some to revisit the past. "Even though it is not merited, some people feel a great regret about not having been able to protect themselves and their families from the violence that was perpetrated upon them. People who are victims of violence often feel that kind of shame that is attached to the victimhood. That inhibits some people from talking about what happened." The atrocities, he said, are beyond words, but if those who aren't ready to talk today are ready to talk tomorrow, staff at Fontbonne's Center for Bosnian Studies would be there.

"Memory is the key to the future. We can have righteous memories that are based upon truth and accountability, or we can have false memories that divide and promote hatred," Moore said. "Denial is entrenching oneself on the wrong side of history in a way that prevents you from engaging in that long process of reckoning with the truth and with the people you have harmed."

Noted Bosnian psychiatrist and author Dr. Esad Boškailo, who survived a series of wartime concentration camps in Herzegovina run by Croatian forces, observed, "When Bosnian refugees came to the US in the early '90s, we carried wounds from having everything taken away from us. Through his work, Ben Moore helped light to enter into those wounds and to restore our trust in humanity."

"Memory is just critical," Moore said. "Memory and the community are almost synonymous with one another. Memory is the binding force that can hold and will hold the Bosnian community in St. Louis together. Because the genocide was directed at erasing memory, forgetting in St. Louis would be the continuation of the perpetrators' aims. Not consciously. Not intentionally. But it would have the same effect."

Contemporary Parallels with Bosnia

Moore saw clear parallels between the destruction of multiethnic Bosnia and the forces of division and racism that are straining the United States today. Back in 1990s Bosnia, political leaders began to sow hatred among people of different ethnicities and demonize those they saw as the "other"—most often Bosnian Muslims. "By making someone the enemy on the basis of a component of their identity, they are able to instill those divisions and then to play upon the kind of discord that arises from that," Moore said.

Many people feel the need to label someone an enemy, Moore said, as a way to consolidate their own identity. And people who feel their identities are under threat by the "other"—such as Muslims in Bosnia or people of color in the United States—become more afraid and susceptible to manipulation. "People are more ready to believe the propaganda and the lies because it plays into their sense of vulnerability," Moore said. "There are a lot of ways to address a person's sense of vulnerability. The way in which Slobodan Milošević did, and which [Donald] Trump is doing, is a particularly evil and destructive way."

But the Bosnians living in St. Louis also represent resilience, even after the trauma of war. "They have remained whole and have been able to continue to have connections with other people. They've also continued to have an investment in their own families and communities," Moore said. For his students, the refugees are living proof that human beings can persist—and indeed thrive—despite past atrocities. "The other thing they see, which I think is a really amazing lesson, is the fact that people who have undergone awful things at the hands of other people don't harbor a sense of revenge or a sense of hatred. And I think that's an incredibly important lesson. The people whom we interview are ordinary people who went through extraordinary events."

Fontbonne University's Dr. Jack Luzkow said that the Bosnian Memory Project also had an indelible impact on the students who took part in interviewing refugees, taking photographs, and ultimately creating the exhibit *Prijedor: Lives from the Bosnian Genocide*. "Students involved in this process came to believe that it was possible not only to study and understand the historical past, but to help shape events in the future by telling the truth about that past," Luzkow said. "Led by Dr. Moore's inspiration, several students entered the teaching profession, where they continued Ben Moore's legacy: restoring memory, giving voice to the voiceless, and seeking to resurrect justice from the ashes of history."

In 2016, Moore secured a $100,000 grant from the National Endowment for the Humanities, which allowed him to expand his community outreach to area schools with large Bosnian student populations. Along with Affton High School teacher Brian Jennings, he developed a course on Bosnian American history that let a younger generation of St. Louis Bosnians contribute their stories to the oral history project. "Having high school students participate in this collection effort is to foster this intergenerational dialogue and to understand better those complex questions of identity that come about when a second generation is having a vastly different experience than what their parents went through," Moore told the local NPR affiliate in a 2017 interview.

Working with Bosnian high school students also helps them get a better sense of their place in the world. "For the children of forced displacement, that relationship to the past is something that is very problematic. But by understanding the memories of their elders, and becoming the repository of those memories,

Dr. Adna Karamehić-Oates is the director of the Center for Bosnian Studies at Fontbonne University in St. Louis, which records and preserves the oral histories of Bosnians who survived the war and genocide.

they can begin to form that imaginative bridge to a place that was very badly damaged during the war but not altogether destroyed," Moore said.

He continued, "A younger person's ability to build upon those memories by returning to the homeland can also become an important way of establishing a relationship to the past. But we are in danger of losing that as younger Bosnians become more Americanized. That would be a great tragedy."

Djenita Pašić, a Louisville, Kentucky, attorney and Bosnian community leader, explained the significance of the Bosnia Memory Project this way: "Immigrants, and especially refugees, usually have too many existential problems at the beginning of their journey in the new home country. It is so hard on so many levels: from mere survival to a new language and new customs, new everything, to eventually adapting and having time to think," she said. "But not one of us would have been able to think up such a 'memory project.' First, because it was too difficult to face the past. And second, Bosnians were never good at talking about themselves. . . . And those Bosnians who eventually resettled in St. Louis survived so many horrors during the aggression on Bosnia in the early 1990s that they were literally frozen," Pašić said.

She called Moore a compassionate leader who understands that preserving even the most troubling memories is a crucial element of self-respect, healing, and growth in Bosnians' new homeland. "The Bosnia Memory Project . . . was the answer to a difficult situation, and it made an important difference in the lives of Bosnians and Americans in St. Louis, and the United States as a whole. We need to know where we came from to be able to know who we are and where we are going. This project gives us the basis for our identity. It is a building block of who we are as Bosnian Americans in this country," she said.

When Moore retired in 2021, Dr. Adna Karamehić-Oates took over as director of Fontbonne's Center for Bosnian Studies. She praised Moore's "unique insight, empathy, and human approach" and planned to build upon his legacy by continuing to engage with the community and recording oral histories. Karamehić-Oates looked ahead to working with second- and third-generation Bosnian Americans in St. Louis and figuring out what the center would mean for them.

"We intend for the center to be a permanent part of St. Louis, for the diaspora, for the community here, and for St. Louis as a city," she said. Along with recording oral histories, Karamehić-Oates was also collecting newspapers such as *Sabah* and *Dijaspora Bošnjačka* and *Plima* magazine—primary resources for St. Louis's Bosnian community.

"We now have Bosnian scholars in multiple disciplines, many of whom were refugees as children, engaging in topics across a spectrum of Bosnian studies and bringing different perspectives and entry points into these topics," Karamehić-Oates said. "They are writing in English for a global audience, opening new lines of inquiry, and helping to dispel common misconceptions about the war and genocide in Bosnia and Herzegovina."

She also wanted the center to convey what displacement means and what its human costs are—and not just for Bosnians. "St. Louis continues to bring refugees from other places into our community. How will the Bosnian story help inform, for example, the Afghan story in St. Louis? What can we learn from both?"

For those who've been displaced, Moore recognized the challenges that come with developing new identities that are more aligned with their new country's culture. In a 2021 story for the University of Missouri Press blog, he wrote, "In the best case, multiple identities enable immigrants and refugees to navigate the varied cultural spaces they traverse—between Sarajevo and St. Louis, for example, or, more commonly, between home and work. But multiple identities can also lead to a painful fracturing of experience. . . . Multiple identities among St. Louis's Bosnians often cause a feeling of alienation that I have come to call cultural homelessness. 'In Bosnia, I'm American,' said one younger Bosnian, 'In America, I'm Bosnian. There is really no place that I can call my own.'

"While their connection to Bosnia remains strong, most have remained in St. Louis because they have no home to go back to," Moore concluded.

Three decades after the war and genocide that destroyed their native land, Bosnians have found a place to call home: St. Louis.

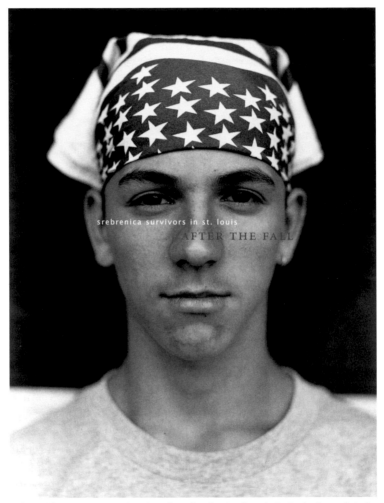

Eldin Besić on the cover of *After the Fall: Srebrenica Survivors in St. Louis*. Cover photo by Tom Maday. Book design by Sam Landers.

AFTERWORD

BY HARIZ HALILOVICH

The book *After the Fall: Srebrenica Survivors in St. Louis* (2000), by Patrick McCarthy with photographs by Tom Maday, was one of the first published studies on the resettlement of Bosnian refugees during the 1990s—a time when their forced migration was still in its initial stages. It not only offered important insights about a demographic (re)creating their new homes in St. Louis but also provided a unique historic opportunity for survivors to voice their experiences of genocide, forced migration, and loss. It allowed them to project their hopes and aspirations for the future in a city and country far away from their shattered homeland.

McCarthy shared the stories and faces of those he wrote about up-close. The book's cover featured a photograph of a young Bosnian refugee wearing a bandana patterned with the stars and stripes of the United States flag. While the horrors this refugee endured in 1990s Europe recalled those of Holocaust survivors a half century before, the young man also looked very contemporary—like Axl Rose, like "one of us"—a member of his generation interested in the same things as his peers in the United States and elsewhere. Using this cover photo, McCarthy sought to (re)humanize refugees, a message he wanted to convey to his global readership.

Since then, *After the Fall* has become an essential reference for anyone interested in the Bosnian refugee diaspora. Many researchers, including myself, have gone beyond reading Patrick McCarthy's foundational work. For those of us who have visited St. Louis, he has been our key research collaborator and

informal mentor. I was very fortunate to meet Patrick in the mid-2000s, during my first fieldwork in St. Louis. In the 15 years since then I have continued to learn from him important facts, changes, and stories about St. Louis Bosnians, as well as the ethics and poetics of researching (former) refugees. Unlike traditional researchers and authors whose publications are usually viewed as finished projects, Patrick's work has remained both alive and applied, the subjects of his book becoming integral parts of the academic and social worlds in St. Louis and beyond.

Patrick McCarthy has influenced and been influenced by the changes Bosnian refugees have gone through, from their initial arrival in St. Louis to their evolution into a distinct, well-integrated, and much-celebrated community in this midwestern city. As a Bosnian diaspora scholar and frequent St. Louis visitor, I have learned that Patrick is a foremost expert on this group. He is regarded by St. Louis Bosnians as an honorary elder and leading community activist—particularly in the cultural domain. Thanks to his work and initiatives, St. Louis has gone on to host numerous Bosnian film festivals, art exhibitions, and literary events.

Like *After the Fall*, the book *Bosnian St. Louis: Between Two Worlds* has been created in partnership with St. Louis's Bosnian community rather than simply written about them. Co-authored with Akif Cogo—a prominent member of the Bosnian St. Louis diaspora and a remarkable individual—this book celebrates people like Akif while remembering and honoring ordinary people who've led extraordinary lives. After surviving the war in Bosnia and coming to St. Louis as a refugee in 2001, 15 years later Akif was recognized by the *St. Louis Business Journal* as one of the "40 under 40" most influential business and community professionals in the region. And this is just one of many formal accolades and awards he and several other Bosnians in St. Louis have received in the place where they've made their new home. Today, there is hardly any field in St. Louis—from business to academia to arts to sports—in which Bosnians have not excelled.

While *Bosnian St. Louis* is based on an in-depth longitudinal study of Bosnian refugees' migration to the United States and traces their journey of becoming Bosnian Americans, it can also be read as a follow-up to *After the Fall*. This new work focuses on the diaspora's stories and remembrances; it looks at how those memories continue to shape the identities of the survivors, even years (and now generations) after genocide and displacement. While the forced displacement of Bosnians from their homeland has resulted in a new emplacement in St. Louis and elsewhere, the idea of the old home continues to resonate in their narratives, performances, language, and everyday lives in St. Louis.

In the absence of records, documents, and material artifacts, individual stories have become the vessels for creating collective memories of Bosnians in St. Louis. Both Akif and Patrick—as well as several other activists and scholars led by Ben

Moore's pioneering and monumental work on the Bosnia Memory Project—have committed to recording and archiving the memories of Bosnians in St. Louis, turning their life stories into official historical records and invaluable data for researchers on the Bosnian diaspora.

The authors give special attention to the diaspora's cultural production, as demonstrated in the book's introduction by the writer Aleksandar Hemon— probably the best-known Bosnian American. The book is also a platform for emerging Bosnian writers, such as Ennis Čehić, a Bosnian Australian author, and Saida Hodžić, a fellow anthropologist at Cornell University. As with any other memory-making process, the genre in which these historical records appear is a blend of both empirical facts and personal recollections. This creatively crafted book brings them together in engaging prose, with lyrical infusion of *sevdah* poetry and a series of photographs. Thus, the book can be simultaneously read as both a scholarly work and a narrative of individual experiences; it can be seen as a historical anthology and even "listened" for longing inscribed in silences between the lines, in the eternal smiles of Nirvana and Selma, to whom the book is dedicated, in the images of Huso and Hatiđa, Subhija and Rešad, Ibrahim and Fazira, Danijela, Alisa, Zerina, Aida, Jasmina, Selma, Amra, Stipo, Enes, Ibro, Muharem, Muhamed, Mirsad, Muška, Dijana, Dženana, and many others whose resilience and courage this work celebrates.

Dear reader, you will be touched, your eyes might even get teary—as it is happening with me while finishing this last sentence—but you will be inspired and enriched by reading this important and timely book.

Hariz Halilovich, social anthropologist and writer, is a professor at the School of Global, Urban and Social Studies, RMIT University, Melbourne. His research includes place-based identity politics, forced migration, politically motivated violence, memory studies, and human rights. The author of four books, including the award-winning *Places of Pain: Forced Displacement, Popular Memory and Trans-local Identities in Bosnian War-torn Communities*, Halilovich has received a number of prestigious research and writing awards in Australia and internationally.

TIMELINE OF BOSNIAN HISTORY AND THE BOSNIAN COMMUNITY IN ST. LOUIS

MEDIEVAL PERIOD (948–1463)

948–952: Bosnia was recorded in *De Administrando Imperio*, a politico-geographical handbook written by the Byzantine emperor Constantine VII in the mid-10th century describing the small land of "Bosona."

1189: The Charter of Ban Kulin defines Bosnia as an independent, sovereign country.

1314–1353: Under Stefan II Kotromanić, Hum (Herzegovina) joins Bosnia, creating the Kingdom of Bosnia.

OTTOMAN PERIOD (1463–1878)

1463: Ottomans conquer Bosnia, then 20 years later, Herzegovina.

A native Slavic-speaking Muslim community emerges and eventually becomes Bosnia's largest ethno-religious group.

LATE 1500s: Following their expulsion from Spain, Sephardic Jews arrive in Bosnia. By the early 1600s approximately 450,000 Muslims, 150,000 Catholics, and 75,000 Orthodox Christians live in Bosnia.

1700s: As the Ottoman Empire suffers losses throughout Europe, Bosnia and Herzegovina's economy declines.

1821: Missouri becomes a state.

EARLY 1830s: An unsuccessful peasant revolt led by Husein Gradaščević seeks autonomy for Bosnia.

1844: Anti-immigrant unrest roils St. Louis.

1850s: Conrad Schmidt, St. Louis's first recorded resident of Bosnian descent, arrives in the city.

AUSTRO-HUNGARIAN PERIOD (1878–1918)

1878: The treaties of San Stefano and Berlin effectively end Ottoman rule, resulting in a pogrom of Bosniaks from Bosnia.

1904: The World's Fair takes place in St. Louis.

1904: St. Joseph Croatian Catholic Church is founded in St. Louis and attracts many Bosnian Croats.

1906: A group of Christian Orthodox Serbs comes to St. Louis from Herzegovina.

1908: Austria-Hungary annexes Bosnia and Herzegovina.

1909: St. Louis's Holy Trinity Serbian Orthodox Church is established as Holy Trinity Serbian Orthodox Church School Parish. The church includes a number of Bosnian Serbs.

1912–1913: The Balkan Wars, two successive military conflicts that deprive the Ottoman Empire of its remaining territory in Europe, take place.

JUNE 1914: Bosnian Serb nationalist Gavrilo Princip assassinates Archduke Franz Ferdinand of Austria in Sarajevo.

JULY 1914: World War I begins.

ROYAL YUGOSLAV PERIOD (1918–1941)

1918: The Habsburg and Ottoman empires dissolve following the end of World War I. The first Yugoslav state is formed under the Serbian Karađorđevic dynasty. Bosnia and Herzegovina becomes part of the Kingdom of Serbs, Croats, and Slovenes.

1929: King Aleksandar declares royal dictatorship over Yugoslavia.

1933: King Aleksandar is assassinated.

WORLD WAR II (1941–1945)

1941–1945: Axis powers invade Yugoslavia. Nazi puppet Nezavisna Država Hrvatska (NDH) is formed, an "independent" State of Croatia that controls most of Bosnia and Herzegovina. Thousands of Serbs, Jews, and Roma, as well as the Croatian and Bosnian Muslims who opposed them, are murdered in NDH concentration camps.

Under the auspices of the Yugoslav Communist Party, Josip Broz "Tito" leads a multinational, anti-Fascist Partisan resistance.

Bosnia becomes the main battleground between Partisan and German forces. The Partisan Army defeats Četnik forces and other collaborators. After the German surrender, reprisal attacks against fleeing anti-Partisan forces kill thousands.

SOCIALIST PERIOD (1945–1991)

1948: Tito breaks with Stalin, and Yugoslavia is expelled from Soviet-led Cominform.

1950: St. Louis's population reaches 856,796.

1951: Stipo Prajz, originally from Kotor Varoš, Bosnia, arrives in St. Louis.

1960: St. Louis's population declines to 750,026.

1961: Using a forged passport, Muharem Bašić escapes from Yugoslavia.

1965: The Gateway Arch is built.

1968: Muharem Bašić and Smajo Cehajić arrive in St. Louis.

1970: St. Louis's population drops to 622,236.

1971: The Croatian Spring reform movement in Yugoslavia is suppressed.

1972: Suljo Grbić arrives in St. Louis.

1974: A new Yugoslav constitution is created, and Tito is elected president for life.

1980: Tito dies and is replaced by a collective presidency that rotates among the six Yugoslav republics.

1982: Ibrišim "Ibro" Dedić arrives in St. Louis.

1984: The Winter Olympics take place in Sarajevo.

1987: Slobodan Milošević assumes leadership in Serbia.

1990: St. Louis's population falls to 396,685, half of what it was in 1950.

NOVEMBER AND DECEMBER 1990: Multiparty elections in Bosnia and Herzegovina bring three national parties to power. Alija Izetbegović becomes president of the collective presidency.

MARCH 1991: At a meeting between Croatian president Franjo Tuđman and Serbian president Slobodan Milošević, the two leaders agree on the partition of Bosnia and Herzegovina between Croatia and Serbia.

JUNE 1991: Slovenia and Croatia declare independence from Yugoslavia. The Yugoslav Army invades.

JULY 1991: Enes and Amra Kanlić arrive in St. Louis with their son, Adi.

AUGUST 1991: The Yugoslav Army attacks Croatia.

Demonstrations take place at St. Joseph Croatian Catholic Church in Soulard.

The United Nations Security Council imposes an arms embargo on Yugoslavia, solidifying the advantage of Serbian forces who control the former Yugoslav Army.

NOVEMBER 1991: Radovan Karadžić's Serbian Democratic Party announces the establishment of a "Serbian Republic" within Bosnia and Herzegovina.

BOSNIAN WAR AND GENOCIDE (1992–1995)

MARCH 1992: A referendum in Bosnia and Herzegovina mandates independence. Many Serb voters boycott the vote.

APRIL 1992: Aggression against Bosnia and Herzegovina occurs, and the siege of Sarajevo commences.

Serb nationalists in Prijedor take over the city government and form a "Crisis Committee."

MAY 1992: Serbian forces begin "ethnic cleansing" in Bosnia and Herzegovina.

An interfaith rally for Bosnia and Herzegovina takes place in downtown St. Louis.

JUNE 1992: Jasmin Hadžić, one of the first Bosnian refugees who would come to St. Louis eight months later, is arrested by Serb authorities in Prijedor and imprisoned at Keraterm concentration camp.

JULY 1992: Hadžić is transferred to the Omarska concentration camp.

SUMMER 1992: The UN secures Sarajevo's airport and opens a road to downtown Sarajevo.

AUGUST 1992: The Western media exposes concentration camps in and around Prijedor.

SEPTEMBER 1992: The UN Security Council expels Yugoslavia from the General Assembly.

OCTOBER 1992: Bosnians protest in front of St. Louis City Hall.

The US Department of State authorizes the admittance of 1,000 Bosnian concentration camp survivors and their families.

NOVEMBER 1992: The *St. Louis Post-Dispatch* publishes a story about Aida Bašić and her mother, Safeta Ovčina.

DECEMBER 1992: The American Bosnian and Herzegovinian Relief Association is founded in St. Louis.

JANUARY 1993: International mediators Cyrus Vance and Lord David Owen propose a plan to divide Bosnia into 10 provinces along ethnic lines.

FEBRUARY 1993: The first group of Bosnian war refugees arrives in St. Louis.

The UN Security Council establishes a war crimes tribunal for the former Yugoslavia.

MARCH 1993: Bosnian Croats, supported by military forces of the Croatian government, begin fighting with Bosnian government forces over the one-third of Bosnia that has not been seized by Serb forces.

APRIL 1993: The Serb Republic (*Republika Srpska*) Army launches an artillery attack on Srebrenica, leaving 56 dead and 73 seriously wounded, including 14 children killed in a school playground.

APRIL AND MAY 1993: The United Nations Security Council declares six UN Safe Areas in Bosnia: Sarajevo, Tuzla, Bihac, Gorazde, Srebrenica, and Žepa.

Fatima Jašarević and her daughters, Mina and Hanifa, leave Srebrenica on an empty UN food convoy truck.

MAY 1993: Bosnian Serbs reject the Vance-Owen Plan.

A second group of Bosnian war refugees arrives in St. Louis.

DECEMBER 1993: Theologian and peace activist Jim Douglass comes to St. Louis, spurring the formation of the St. Louis Interfaith Project for Peace in Bosnia.

MARCH 1994: The Bosnian government and Croatian forces sign a US-brokered agreement, ending hostilities between the two groups.

An interfaith group organizes Walk for Peace through St. Louis's midtown.

AUGUST 1994: Vildana Bašagić, sponsored by the St. Louis Bosnian Student Project, arrives in St. Louis.

St. Louis nurses Elsie Roth and Kathy Bauschard travel to Sarajevo.

SEPTEMBER 1994: The Bosnian Cultural Club (*Bosanski Klub*) opens in St. Louis.

OCTOBER 1994: Serb forces launch an attack on the UN Safe Area of Bihac.

NOVEMBER 1994: NATO launches air attacks against a Serb airfield. Serbs detain UN peacekeepers in response.

MAY 1995: Croatia launches Operation Storm to recapture parts of Croatian territory occupied by rebel Serbs.

The UN orders the removal of Serb heavy weapons around Sarajevo. Serbs ignore the order, prompting NATO attacks against a Serb ammunition depot. Serbs respond by shelling UN Safe Areas, including Tuzla, where 71 people are killed, most of them young.

NATO warplanes attack more ammunition depots. Serbs take additional UN peacekeepers hostage—a total of 370.

A second Bosnian nonprofit is formed in St. Louis: SDA St. Louis USA for Bosnia and Herzegovina.

JULY 1995: Serb forces attack the UN Safe Area of Srebrenica, systematically murdering 8,372 Bosniak males and expelling women and children in what is later ruled a genocide.

NATO launches an air campaign against Serb forces around Sarajevo and other UN Safe Areas.

AUGUST 1995: Hatiđa Salihović gives birth to her daughter, Dženana, in Tuzla, after being expelled from Srebrenica.

Nirvana Zeljković is killed while playing in her Sarajevo neighborhood.

SEPTEMBER 1995: More than 1,000 refugees from Bosnia are now living in St. Louis.

DECEMBER 1995: The US-sponsored Dayton Peace Accords ends the Bosnian war and creates two entities in Bosnia and Herzegovina: a Federation of Bosniaks and Croats and a *Republika Srpska*. An international peacekeeping force is deployed.

POSTWAR PERIOD (1996–PRESENT)

OCTOBER 1996: A third registered Bosnian nonprofit, Socijalni Klub Nasa Bosna, is created in St. Louis.

FEBRUARY 1997: *Plima* magazine is first published in St. Louis.

1997: Bosna Gold restaurant opens as the first Bosnian business in St. Louis owned by former refugees.

MAY 1997: St. Louis's Bosnian community tops 3,000.

AUGUST 1998: Selma Dučanović disappears in St. Louis and is found murdered.

1999: Bosnians are now the largest group entering the US with refugee status. More than 19,000 individuals are admitted.

2000: St. Louis's population reaches 348,189.

MARCH 2000: S. D. Bosna, St. Louis's first Bosnian sports club, is formed.

JULY 2000: The Islamic Community Center, St. Louis's first Bosniak religious institution, is established.

MAY 2002: The Bosnian Chamber of Commerce is created.

2003: The Bosnian TV show *Vozdra* (later renamed *Ovdje i Sada*) launches on St. Louis's channel 10.

2004: Bosnian Islamic Center of St. Louis is formed.

MAY 2004: The periodical *Bosniak Diaspora* (*Dijaspora Bošnjačka*) is first published in St. Louis.

FALL 2005: The Bosnian weekly newspaper *Sabah* relocates from New York to St. Louis.

FEBRUARY 2006: Novella, St. Louis's first Bosnian bookstore, opens.

NOVEMBER 2006: The Bosnia Memory Project is founded at Fontbonne University.

NOVEMBER 2007: The exhibit *Prijedor: Lives from the Bosnian Genocide* opens at the St. Louis Kaplan Feldman Holocaust Museum.

MAY 2008: The minaret at the Islamic Community Center is dedicated.

JULY 2008: Former Bosnian Serb leader Radovan Karadžić is arrested on war-crimes charges in Belgrade after nearly 13 years on the run.

2009: The Bosnian community now has 33 formal and informal organizations operating in St. Louis.

2010: The St. Louis Islamic Center is formed.

MAY 2011: Serbian authorities arrest former Bosnian Serb military chief Ratko Mladić.

NOVEMBER 2012: In honor of the newspaper, Sabah Day is proclaimed in St. Louis County.

FEBRUARY 2013: The Missouri House of Representatives passes the Resolution on Genocide in Prijedor and Srebrenica.

MAY 2013: A UN tribunal at The Hague finds six former Bosnian Croat leaders guilty of war crimes and crimes against humanity during the 1990s Balkan wars.

NOVEMBER 2013: The Bosnia and Herzegovina vs. Argentina soccer game in St. Louis is attended by thousands of Bosnian fans.

MAY 2014: *Bosnian Journeys: Generations* is performed by the Saint Louis Symphony, and the art exhibit *Bosnian Born* opens at Fontbonne University.

AUGUST 2014: A Bosnian American Studies program begins at Affton High School.

A Bosnian Sebilj is dedicated to the city of St. Louis.

APRIL 15, 2015: Bosnian Day is designated in Missouri.

2015: The Center for Bosnian Studies (formerly known as the Bosnia Memory Project) Civic Courage Award is founded and awarded to Kemal and Vesna Kurspahić.

MARCH 2016: A UN tribunal in The Hague finds former Bosnian Serb leader Radovan Karadžić guilty of genocide and war crimes, including the genocide in Srebrenica.

NOVEMBER 2017: Former Bosnian Serb military commander Ratko Mladić is found guilty of genocide and crimes against humanity during the Bosnian war. He is sentenced to life imprisonment.

2017: More than 2,000 Bosnian-owned businesses are operating in St. Louis.

2022: The 30th anniversary of Bosnian statehood and the beginning of the war and genocide is observed in St. Louis.

ACKNOWLEDGMENTS

Co-authoring a book is a wonderful collaborative process. Writing a book like this requires broad community participation.

We gratefully acknowledge and thank all our interview subjects who allowed us into private places of memory to tell a public story. Any mistakes are the sole responsibility of the authors.

We particularly thank our spouses, Jasna Meyer and Amina Hodžić, for their patience and tolerance during the seven years we worked on the project.

Special thanks to our superb editors, Lauren Mitchell and Kristie Lein, whose skills and expertise enhanced the text with clarity and cohesion.

We appreciate beyond words the assistance, insight, support, and friendship of the following individuals who helped make this book possible.

Edina Ahmetović	Danijela Borić
Elvir Ahmetović	Esad Boškailo
Kenan Arnautović	Nasja Bošković Meyer
Reuf Bajrović	Zdeslav Bošković
Aida Bašić	Alden Burić
Muharem Bašić	Tahir Cambis
Azra Bećirović	Congressman Russ Carnahan
Azra Blažević	David Cassens

Ajla Cogo

Atil Cogo

Bedrija Cogo

Đenana Cogo

Betsy Cohen

Anna Crosslin

Rita Csapo-Sweet

Novak and Ljiljana Cvijanović

Ibro Dedić

Almira Delibegović-Broome

Amra Delić

Azem Dervišević

Tanya Domi

Hajrudin Dučanović

Alija Džekić

Šukrija Džidžović

Adis Elias Fejzić

Nerko Galešić

Ashley Glenn

Rabbi Jim Goodman

Ermin Grbić

Senada Grbić

Suljo and Ermina Grbić

Dermot Groome

Dijana Groth

Hariz Halilovich

Imam Muhamed Hasić

Damir Husamović

Aleksandar Hemon

Hamza Hodžić

Refik Hodžić

Zemina Hodžić

Ivana Horvat

Hamdija and Rabija Jakubović

Juso and Fatima Jašarević

Brian Jennings

Eldin Kajević

Enes and Amra Kanlić

Dženeta Karabegović

Amir Karadžić

Edina Karahodžić

Adna Karamehić-Oates

Ajlina Karamehić-Muratović

Hidajet Kardašević

Ron Klutho

Suada Kovačević

Laura Kromják

Kadro Kulašin

Imam Enver Kunić

Kemal and Vesna Kuršpahić

Dr. Frances Levine

Jack Luzkow

Tom Maday

Zdenko Mandušić

Elvir Mandžukić

Nefira Mašić

Anne McCarthy	Joe Puleo
Kate McCarthy	Nedim Ramić
Kevin McCarthy	Consul General Elvir Rešić
Mia McCarthy	Elsie Roth
Mina Memić	Elma Rovčanin
Leo V. Mitchell	Leila Sadat
Ben Moore	Maja Sadiković
Doug Moore	Dženana Salihović
Sejad Muhić	Mirsad Salihović
Dijana Mujkanović	Aida Šehović
Murat Muratović	Jonathan Segal
Esed Mustafić	Davor and Josipa Šopf
Denis Nasufović	Josh Stevens
Hasan Nuhanović	Danielle Stevens
Beriz and Dževida Nukić	Emir Suljagić
Dan O'Callaghan	Imam Eldin Suša
Elvis Orić	Lejla Sušić
Huso and Sadika Orić	Edvin Turan
Muška Orić	Emily Underwood
Hatiđa and Ibro Osmanović	Ibrahim and Fazira Vajzović
Safeta Ovčina	Rebecca van Kniest
Djenita Pašić	Rich Vaughn
Elvedin Pašić	Phillip Weiner
Ann Petrila	Nasja Wickerhauser
David Pettigrew	Debbie Wiser
Safija Dedić Poturković	Belma Zeljković-Kovačević
Stipo Prajz	Zeljković family

INDEX

ABOUT THE AUTHORS

Patrick McCarthy is a specialist on Bosnian immigration and the history of Bosnia and Herzegovina. He has worked with the Bosnian community since 1993, providing resettlement assistance to refugees fleeing the war and genocide in Bosnia and Herzegovina in the 1990s. In 1994, McCarthy traveled to wartime Bosnia to deliver humanitarian aid and support. That same year he founded the St. Louis Bosnian Student Project, which located scholarships for Bosnian refugee students at area colleges and universities.

McCarthy is co-author with photographer Tom Maday of *After the Fall: Srebrenica Survivors in St. Louis* (2000), a companion volume to a yearlong exhibit at the Missouri History Museum. He is also co-author and general editor of *Ethnic St. Louis* (2015).

An honorary member of the Bosnian Herzegovinian American Academy of Arts and Sciences, McCarthy was a contributor to the traveling exhibit *Prijedor: Lives from the Bosnian Genocide*. He is the founder and facilitator of the Working Group for Bosnia and Herzegovina, an advocacy organization that promotes security, democracy, and rule of law for Bosnia and Herzegovina and its people.

McCarthy is a professor and associate dean of libraries at Saint Louis University, where he directs the Medical Center Library.